AROUND
RUGELEY
From Old Photographs

First published 1988
This edition published 2009

Copyright © Thea Randall & Joan Anslow, 2009

Amberley Publishing
Cirencester Road, Chalford,
Stroud, Gloucestershire, GL6 8PE

www.amberleybooks.com

British Library Cataloguing in Publication Data.
A catalogue record for this book is available from the British Library.

ISBN 978 1 84868 500 0

Typesetting and origination by Amberley Publishing
Printed in Great Britain

AROUND
RUGELEY
From Old Photographs

THEA RANDALL &
JOAN ANSLOW

AMBERLEY

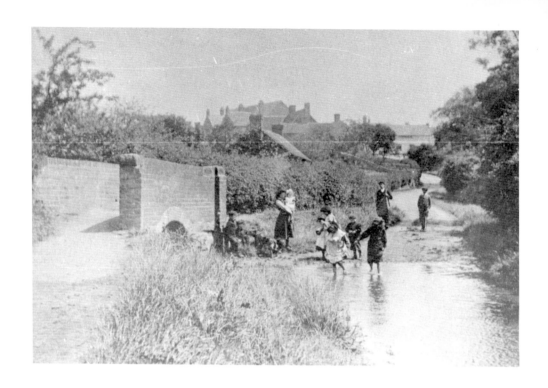

INTRODUCTION

Rugeley and its surrounding villages are set in the beautiful Trent Valley and Cannock Chase, which was once a medieval hunting ground. It was predominantly an agricultural area with many agriculturally related industries sited in Rugeley itself. During the early nineteenth century coal-mining was developed at Brereton. However, although by the mid nineteenth century many Rugeley men were miners, large numbers of them were employed away from Rugeley and Brereton at Cannock and Hednesford. In the late nineteenth century and early twentieth century, brickmaking was an important industry in neighbouring Armitage. Today, however, it is known for the world famous Armitage Shanks, whose forerunner was Edward Johns Sanitary Earthenware Pottery.

Rugeley itself was a quiet market town, at its liveliest once a year at the June Horse Fair, when the place was full of gypsies trotting horses up and down and Irishmen buying and selling horse-flesh. This, and the pleasure fair which followed it, brought in much business to Rugeley's shops and public houses. Farmers who came to sell horses stayed overnight in local hostelries but were very careful with their sale money, hiding it in their boots as there were so many rogues about. In the mid nineteenth century Rugeley became notorious when Dr William Palmer, a local medical practitioner, was tried and found guilty of the murder of John Parsons Cook, a racing associate.

He was hanged at Stafford in 1856. Such was the notoriety of the case that the town petitioned to have its name changed. The Prime Minister suggested it be renamed after him, but as the Prime Minister of the time was Palmerston the local inhabitants declined the offer.

Rugeley's hinterland was comprised of small, largely agricultural villages, dominated by large and small country houses: Beaudesert, Bishton, Blithfield, Ingestre, Shugborough and Wolseley. Their influence was extensive. These great families founded schools and gave their names to Rugeley streets, employed people as domestic servants and estate workers, and were landlords to numerous ordinary people. Many of these villages fitted the classic pattern of rural England: the parish church, the village green, the village school, the shops and the activities peculiar to village life.

Communications have always been important in this area. The Trent and Mersey canal accompanies the River Trent for many miles, and provided work, leisure and occasionally tragedy. The Trent Valley Railway, one of the two lines which meet at Colwich Junction, cuts through the river valley landscape.

The close proximity of the open spaces of Cannock Chase also influenced the lives of local people. In the nineteenth and early twentieth centuries, when it was not easy to make long journeys, it was popular for outings and picnics. On a more sombre note the Chase has been used extensively by the military for manoeuvres, and in the First World War two large army camps were built at Rugeley and Brocton. The inhabitants of Rugeley became well used to the sight of military uniforms.

This collection of photographs covers the period from the 1860s to the early 1950s. This period saw relatively little change, the new pits and housing estates not coming until the 1950s and 1960s. Here we can only give a flavour of an area where people today have a strong interest in the past. Some of the smaller villages have few surviving photographs, while the bigger ones such as the Haywoods and Armitage have so many it has proved difficult to provide an even spread. Many excellent photographs have had to be omitted through lack of space. However, we hope that the contents of this book will go some way towards providing a picture of the people and events in and around Rugeley during this span of ninety years.

Thea Randall
Joan Anslow
1988

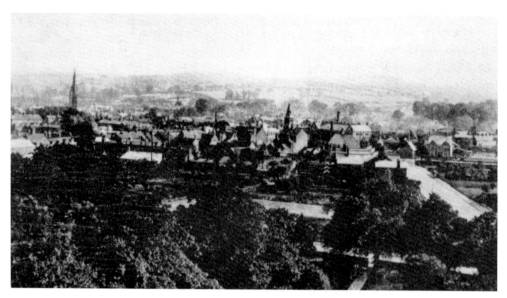

A BIRDS EYE VIEW OF RUGELEY TOWN from the top of the church tower, *c.* 1905.

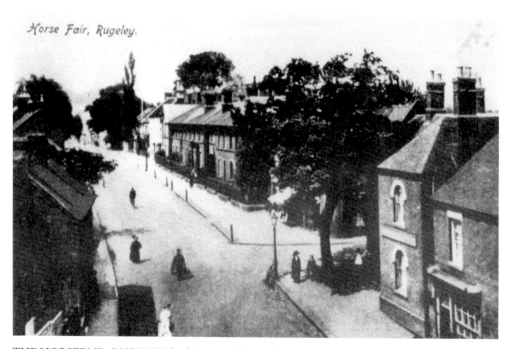

Horse Fair, Rugeley.

THE HORSEFAIR, RUGELEY, looking north from the railway bridge, *c.* 1905. The hitching posts for the horses show clearly on the edge of the pavement.

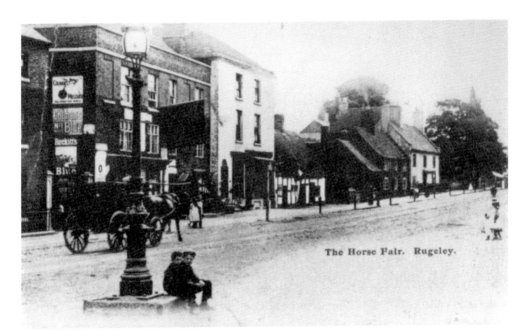

THE HORSEFAIR, looking south, *c.* 1905. The site of the lamp post marks the original position of the Maypole.

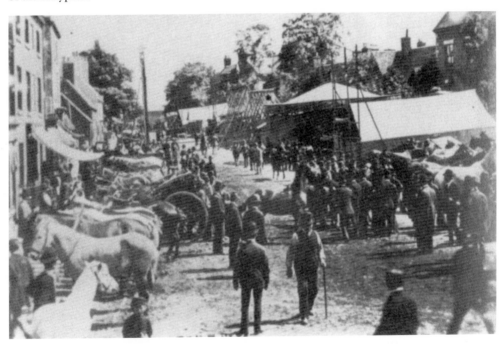

THE HORSE FAIR, Rugeley, *c.* 1900. This fair was held annually in June in the Horsefair and was combined with a pleasure fair. Irish horse dealers brought horses from Ireland and would trot them up and down to show off their paces.

SHEEP FAIR, Rugeley, *c.* 1900.

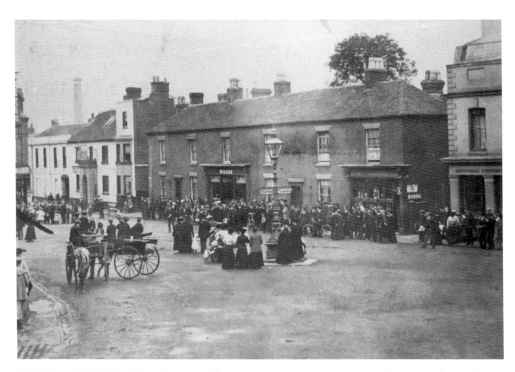

RUGELEY MARKET PLACE, 1902. The crowd of people are seen waiting to welcome home troops returning from the Boer War.

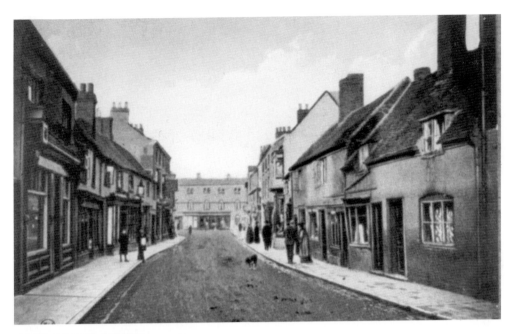

UPPER BROOK STREET, *c.* 1905.

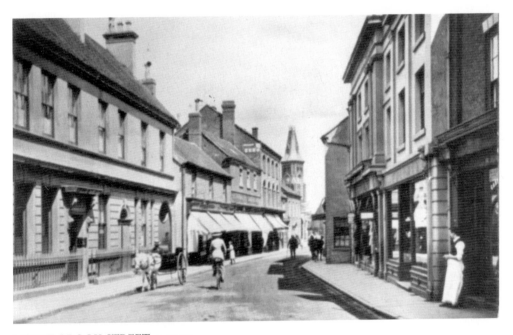

LOWER BROOK STREET, *c.* 1905.

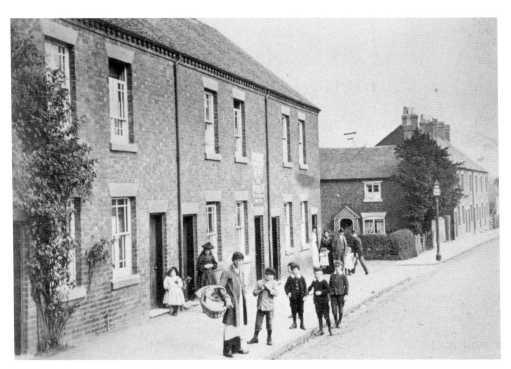

COLTON ROAD AND MILLINGTON STREET, Rugeley, *c.* 1910.

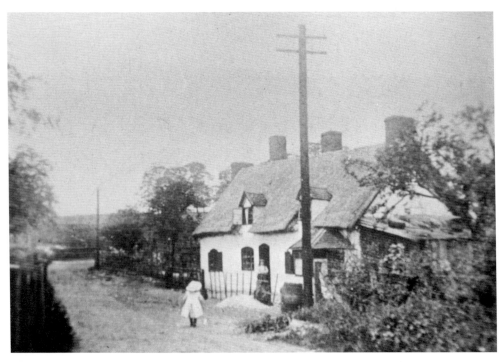

COTTAGE IN GREEN LANE, Rugeley, 1911. This was the home of George Upton, the town crier.

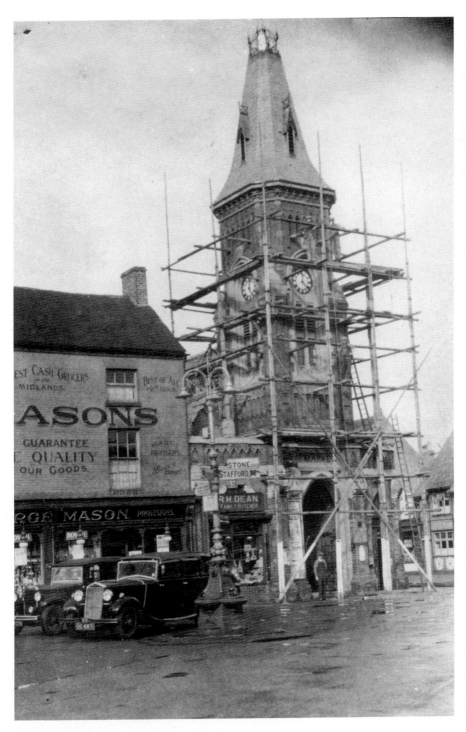

RUGELEY TOWN HALL CLOCK TOWER, built in 1879. The ironwork was made at a local foundry. It is seen here being repaired in 1919. Mr Jones from Colton is on the scaffolding.

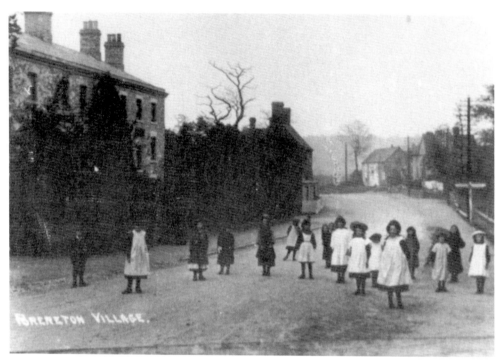

BRERETON VILLAGE, *c.* 1905. Brereton House, a late eighteenth-century house, is in the background.

BRERETON VILLAGE, *c.* 1905, with the village shop on the right of the picture.

LONGDON VILLAGE, *c.* 1910.

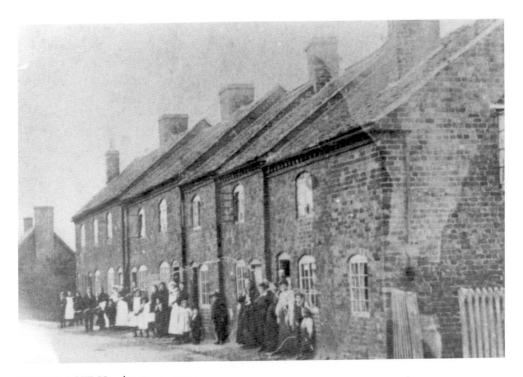

EDEN'S ROW, Handsacre, *c.* 1910.

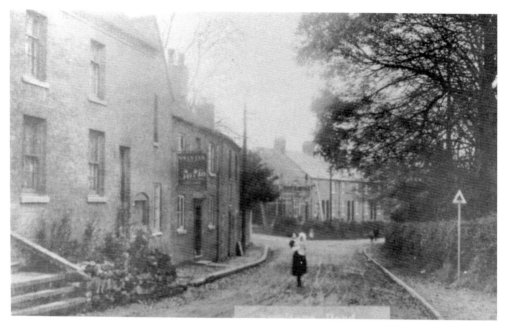

VILLAGE STREET IN ARMITAGE, *c.* 1918.

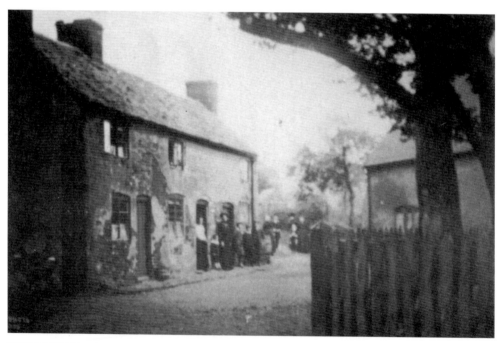

THE PINFOLD, COLTON, *c.* 1900. The tree stood on what is now the site of the war memorial.

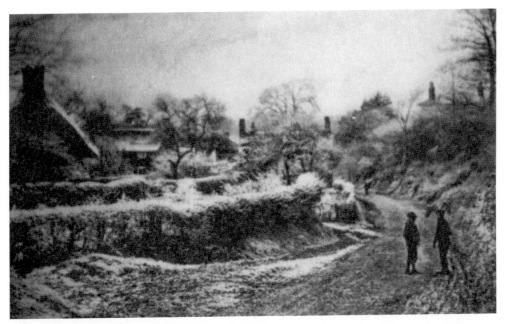

HOLLOW LANE, Colton, *c.* 1905. The name indicates the great age of this road which must date from medieval times.

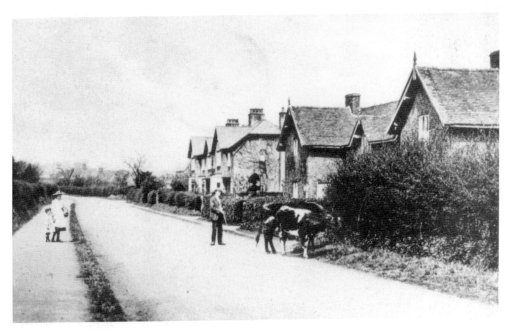

BISHTON, *c.* 1905.

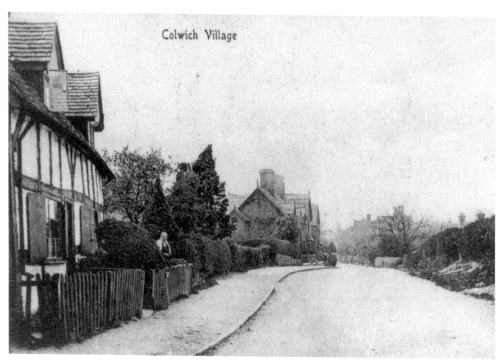

COLWICH VILLAGE, *c.* 1905. The main road from Lichfield to Stone now bypasses the village.

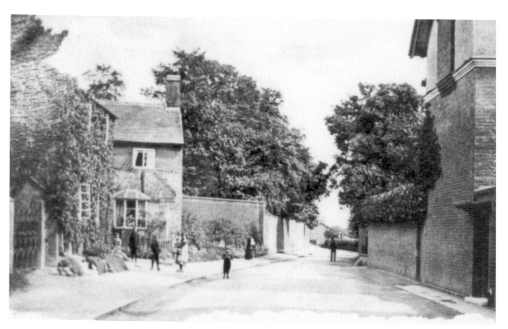

STATION ROAD, Little Haywood, *c.* 1905.

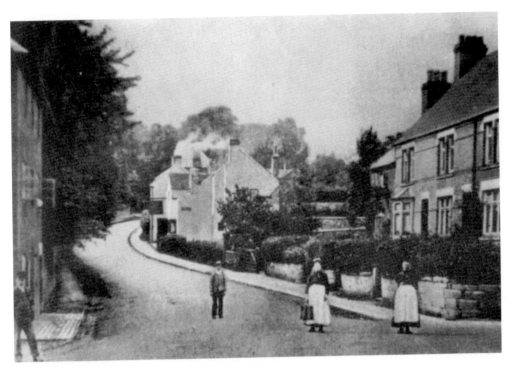

AT THE CROSSROADS in Little Haywood, *c.* 1905.

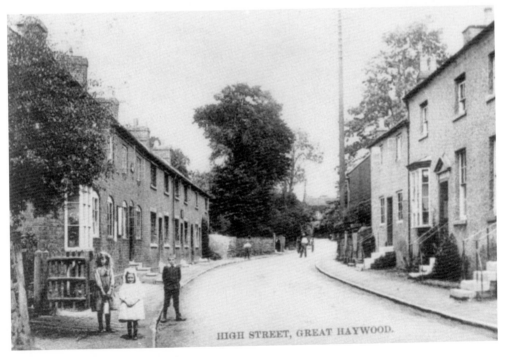

HIGH STREET, Great Haywood, *c.* 1905.

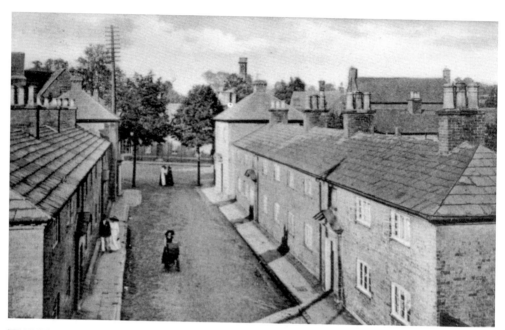

TRENT LANE, Great Haywood, taken from the railway bridge and looking towards the Square, c.1905.

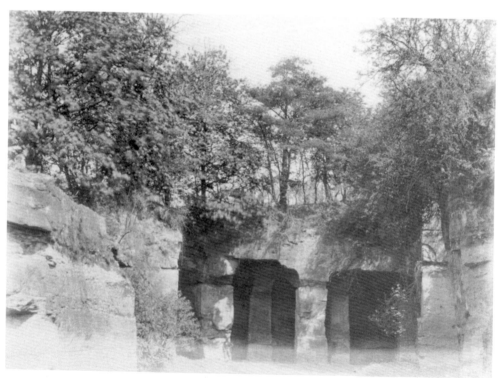

THE CLIFFS, Great Haywood, 1863.

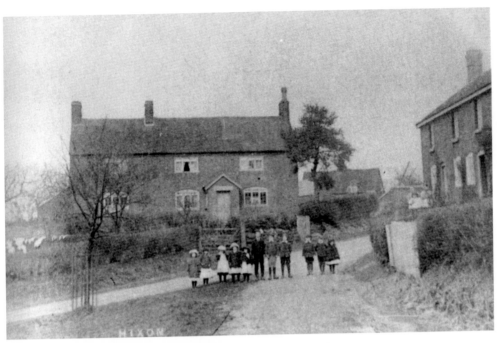

HIXON VILLAGE GREEN, 1906, with the Jubilee tree planted in 1897.

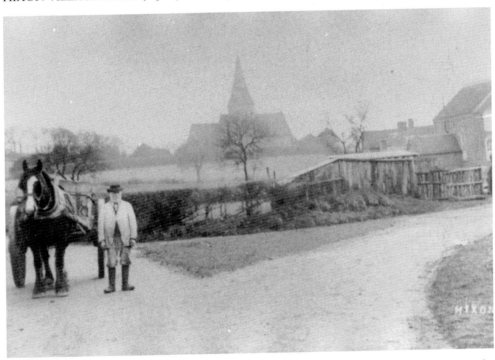

HAMMOND'S CORNER, Hixon, with Mr Peace and his cart in 1902. St Peter's church can be seen in the background.

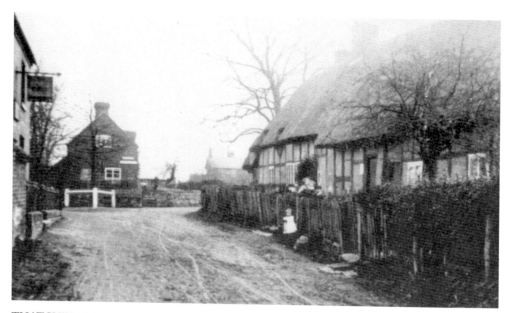

THATCHED COTTAGES in Stowe-by-Chartley, 1905.

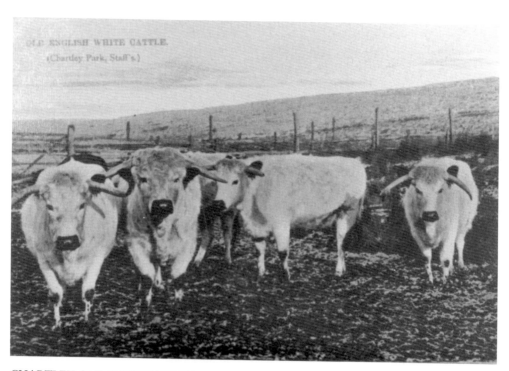

CHARTLEY OLD ENGLISH WHITE CATTLE in Chartley Park, 1923.

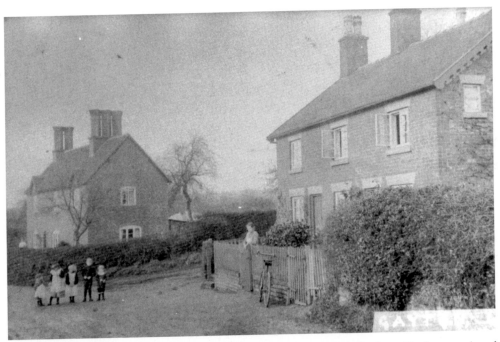

GAYTON VILLAGE, *c.* 1905. Although very faded this is one of the few old photographs of Gayton to survive.

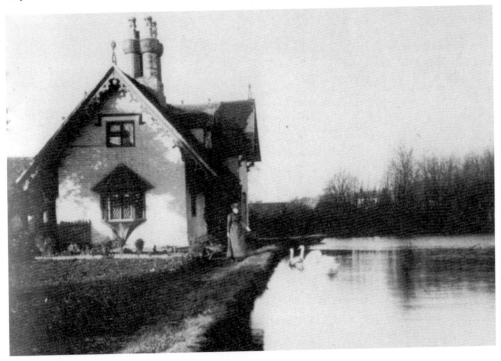

POOL COTTAGE beside the canal basin at Weston in 1910.

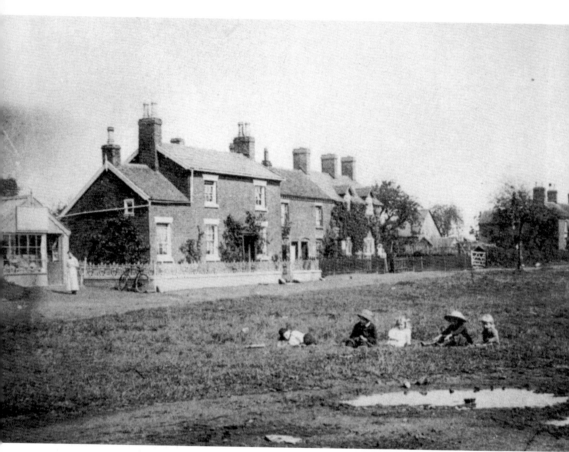

WESTON VILLAGE GREEN, *c.* 1905.

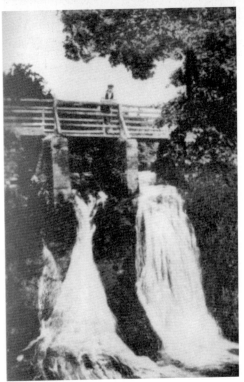

THE OAK TREE NAMED BAGOTS
WALKING STICK and the Bagot goats in
Bagot's Park in the 1950s. According to Bagot
family tradition the goats were presented to
Sir John Bagot by Richard II in appreciation
of the hunting which he had enjoyed in
Bagot's park. The tree, the last surviving of the
ancient oaks in the Park, was blown down in
the gales of February 1988.

THE WATERFALL AT SLITTING MILL,
Rugeley, c.1910.

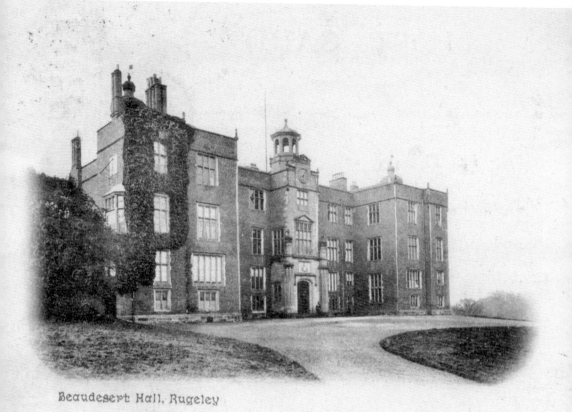

Beaudesert Hall, Rugeley

BEAUDESERT HALL, situated on Cannock Chase. This was the home of the Paget family, later Marquesses of Anglesey. Henry Paget, who became the first Marquis of Anglesey, lost a leg while fighting at Waterloo with Wellington and commented 'By God, Sir, I've lost my leg!', to which Wellington replied 'By God, Sir, so you have!' The Hall was demolished in 1932. Interior woodwork, fire places and windows were shipped to Australia where a house called 'Carrick Hill' was specially built to accommodate them. It was built in the style of an Elizabethan manor.

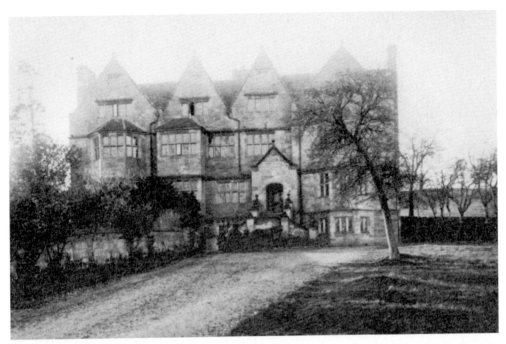

WESTON HALL, *c.* 1912, when this massive Jacobean house was a branch of the County Lunatic Asylum of Stafford. During the Second World War it was requisitioned and, because of rumours that it was haunted, Land Army girls slept in tents in the grounds rather than in the Hall itself.

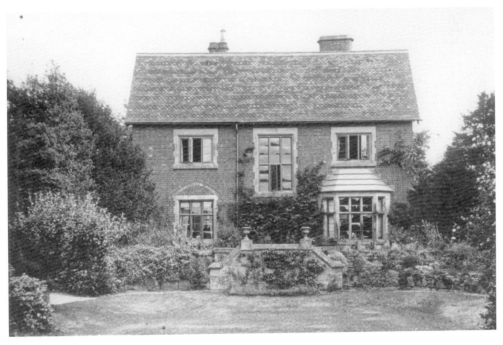

THE VICARAGE, Weston, *c.* 1908.

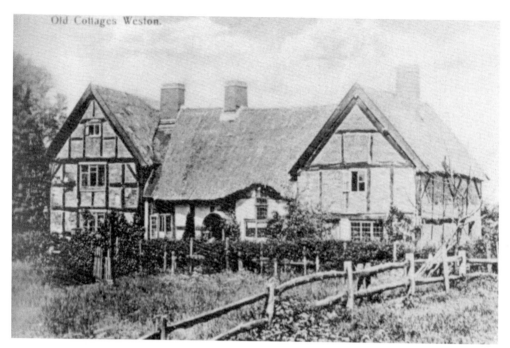

OLD COTTAGES IN WESTON, now one house and known as the Manor House.

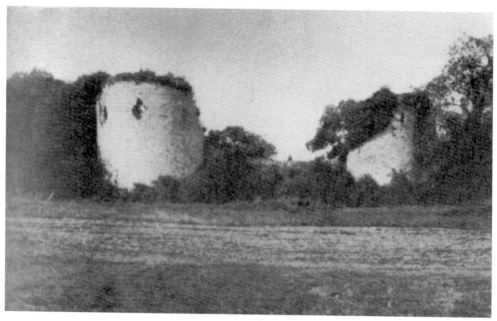

CHARTLEY CASTLE, in 1914, built in the early thirteenth century by Ranulph Blundeville, Earl of Chester.

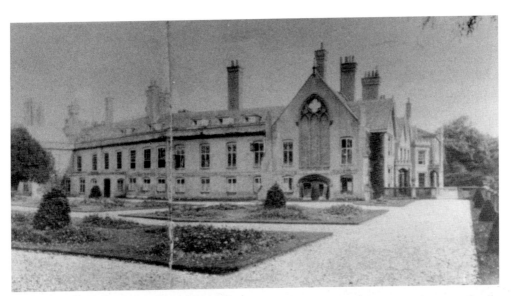

THE NORTH FRONT OF BLITHFIELD HALL, *c.* 1880. The Hall has been in the Bagot family since 1367 and the north front was built around 1740 with some alteration *c.* 1820. Note the Victorian garden chairs.

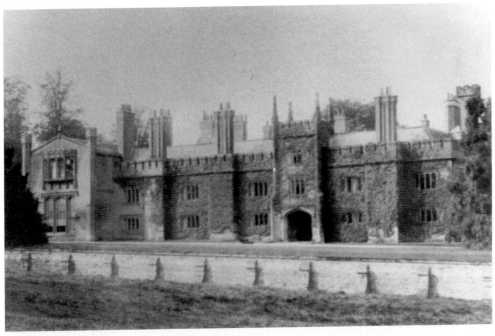

THE SOUTH FRONT OF BLITHFIELD HALL in 1903 which dates from the sixteenth century, apart from additions to the west. The beams above the Great Hall's plaster ceiling date from the fifteenth century.

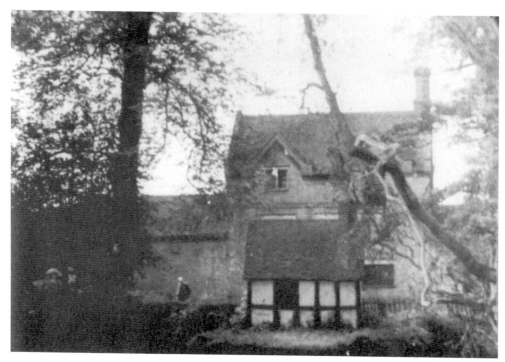

BLITHFIELD MILL which disappeared when the reservoir was created in 1953.

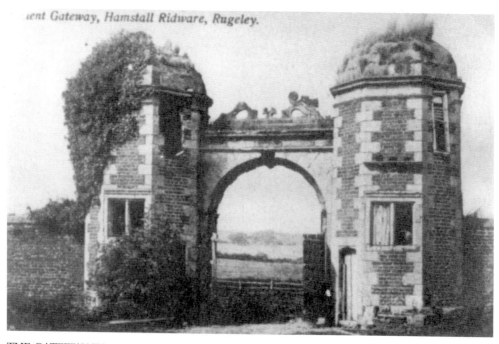

ent Gateway, Hamstall Ridware, Rugeley.

THE GATEWAY TO HAMSTALL HALL, 1920, which formerly belonged to the Fitzherbert family.

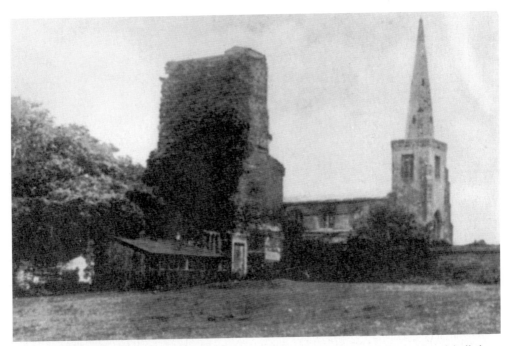

HAMSTALL RIDWARE, *c.* 1910. The isolated tower used to be part of a medieval hall, long since demolished.

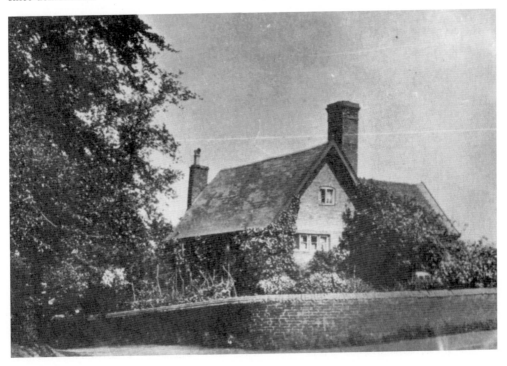

THE STONE HOUSE, Armitage, 1920.

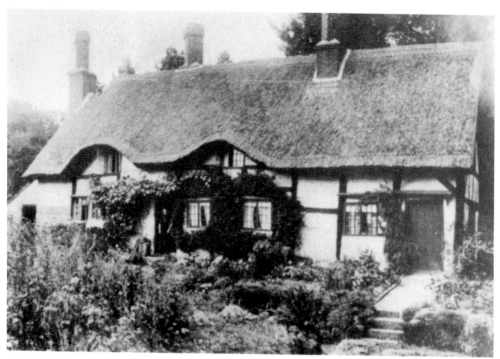

THATCHING LODGE COTTAGE, Armitage.

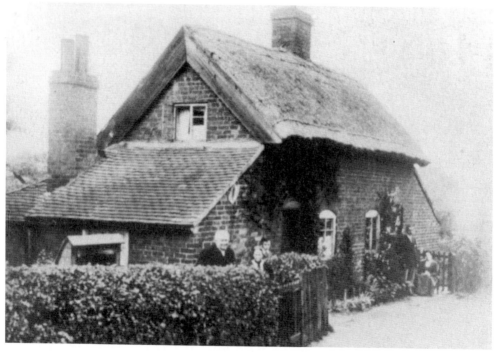

COTTAGES, now demolished, in Boathouse Lane, Armitage, *c.* 1900.

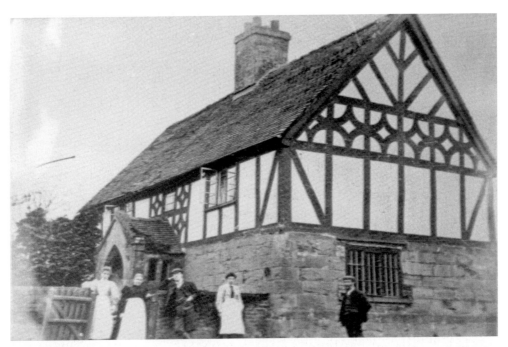

BIRCHENFIELDS as it was around 1900. The timbers of the upper part of the house have since been covered.

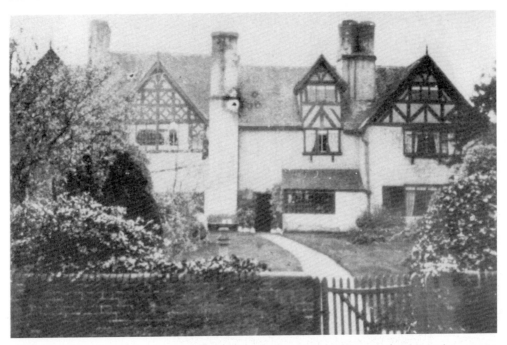

HANDSACRE HALL, 1903. This timber-framed house was built at some time from 1320 onwards.

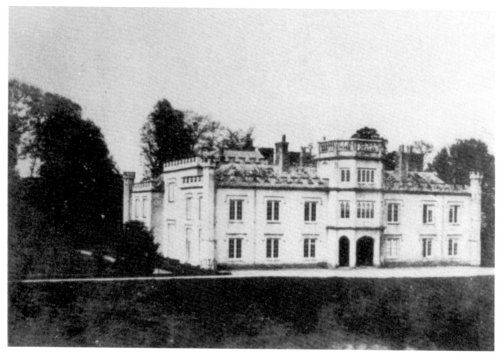

WOLSELEY HALL, home of the Wolseley family from the thirteenth century, was burned down in the 1950s.

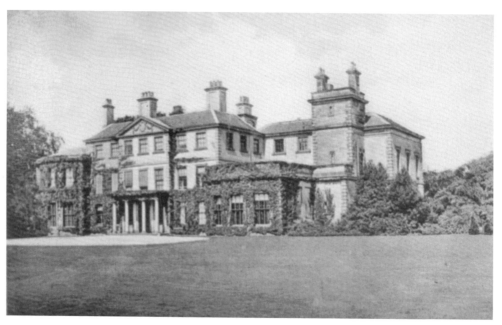

BISHTON HALL in 1906, a fine Georgian mansion.

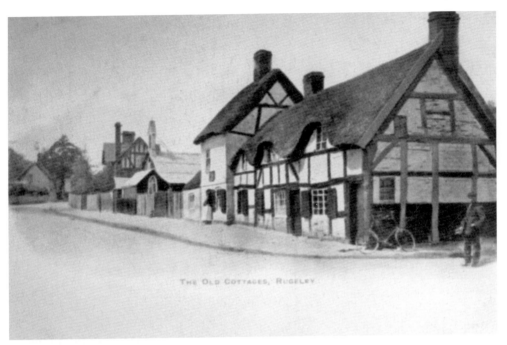

THIS VIEW SHOWS THE HALF-TIMBERED COTTAGES on the corner of Elmore Lane, once Chapel Street, and Horsefair, Rugeley, in 1900. Next to them is St Mary's Mission Chapel and Holly Lodge, one of the lodges to Hagley Hall.

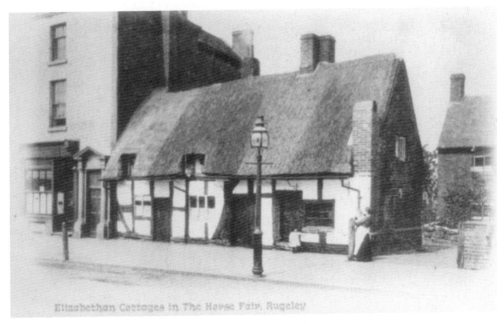

THESE TIMBERED COTTAGES were in Horsefair, Rugeley, 1910.

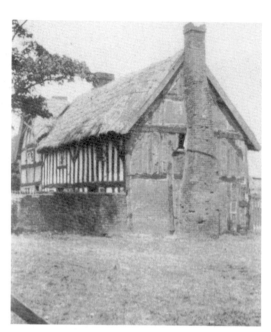

ARBOUR TREE COTTAGES was on the corner of Bryants Lane and Market Street, Rugeley. The cottage was built *c.* 1578 and demolished in 1897.

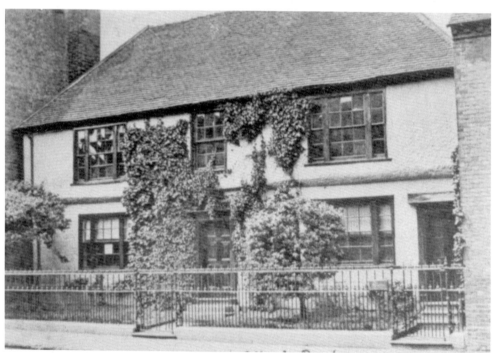

WILLIAM PALMER, a doctor in Rugeley, was hanged in 1856 for poisoning John Parsons Cook, although it was suspected he poisoned many others too. This was his house, photographed in 1900. It later became the town post office and then a shop. It is still there in 1988 with shop fronts on the ground floor.

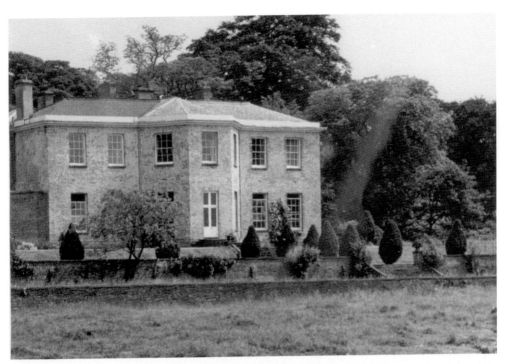

BLITHFIELD RECTORY, a fine Georgian house, burned down in the 1960s.

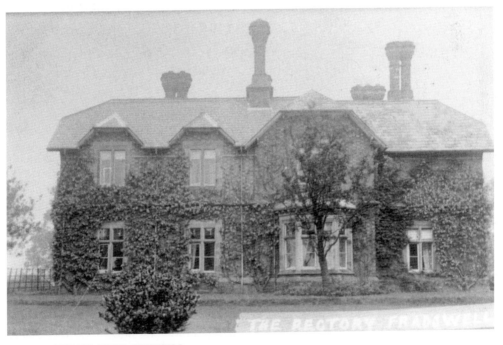

THE RECTORY AT FRADSWELL, *c.* 1905.

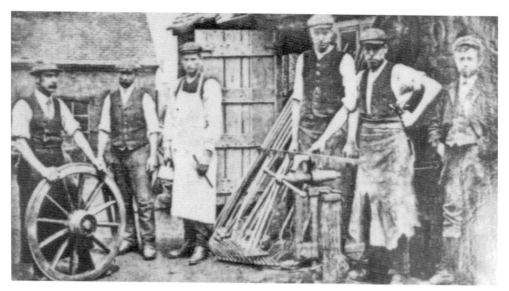

MR WHITE, an agricultural engineer, had this shop in Lichfield Road, Handsacre. He is pictured here holding the wheel and Mr Allen Hall who worked for him is also shown. Mr White was a Methodist lay preacher for seventy years.

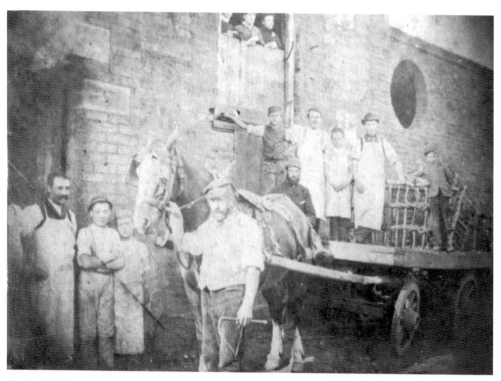

EMPLOYEES OUTSIDE EDWARD JOHNS & CO. LTD., Armitage Sanitary Pottery *c.* 1880. Edward Johns later became Armitage Shanks Ltd.

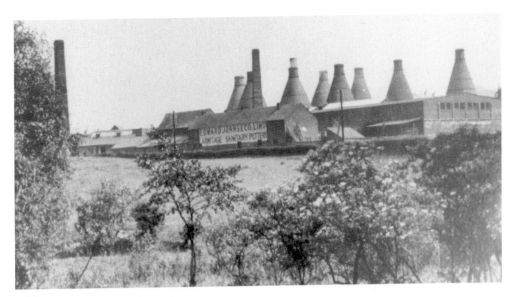

EDWARD JOHNS' SITE in 1926.

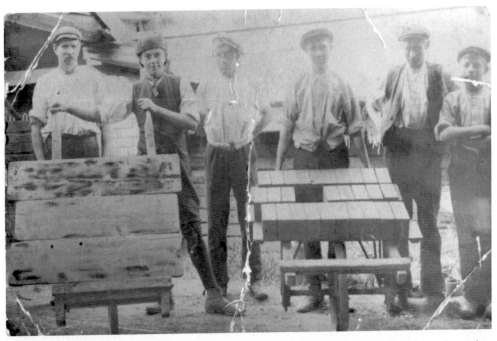

ONE OF THE MANY BRICKWORKS IN ARMITAGE AND HANDSACRE situated at what is now the corner of New Road and Millmoor Avenue. It continued to make bricks during the Second World War and was purchased by Edward Johns Pottery.

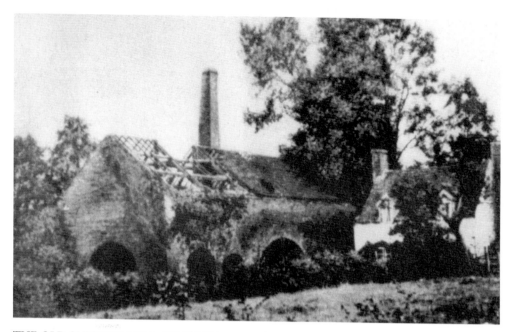

THE OLD SLITTING MILL, RUGELEY, 1902. This old rolling mill was demolished in the early 1930s to make way for Slitting Mill Pumping Station.

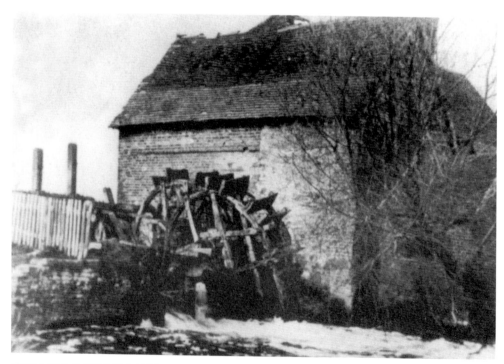

THE MILL IN WADE LANE, Mavesyn Ridware.

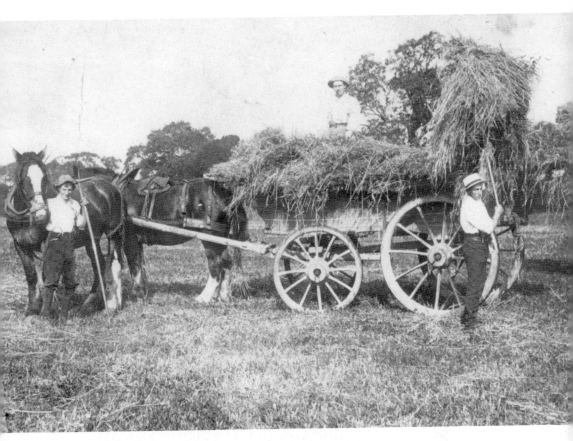

HAYMAKING IN HIXON in the early 1920s.

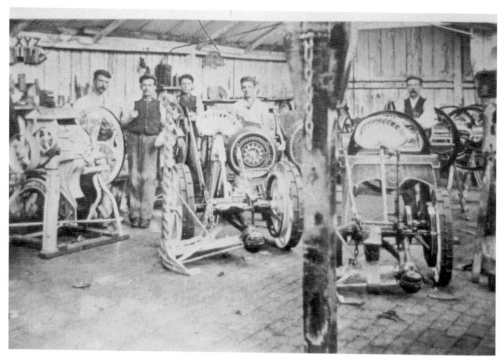

THE ALBION WORKS, Market Street, Rugeley, which made agricultural implements and garden tools, *c.* 1890.

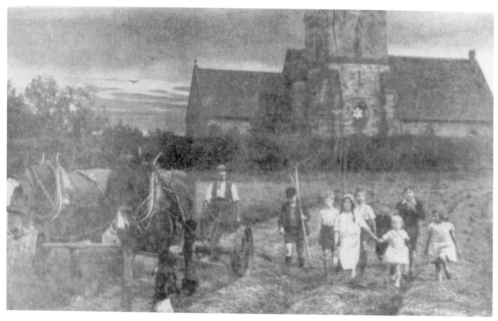

CHILDREN RETURNING HOME FROM HAYMAKING in Hixon, *c.* 1935. St Peter's church is in the background.

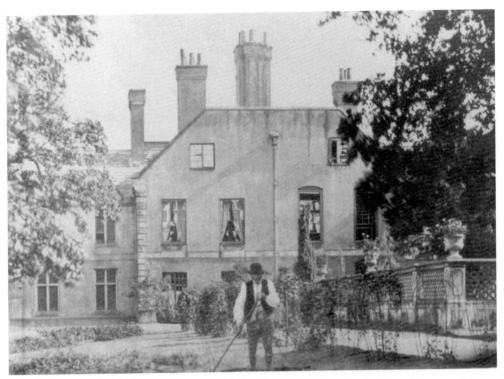

MR HARDING, the gardener at Blithfield Hall, working in that part of the garden now known as the Pleasure Gardens, 1865.

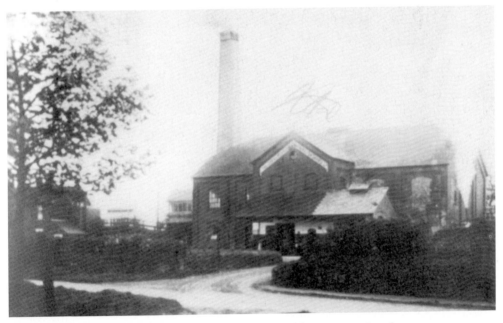

THE MILK FACTORY AT WESTON which was opened between 1908 and 1912.

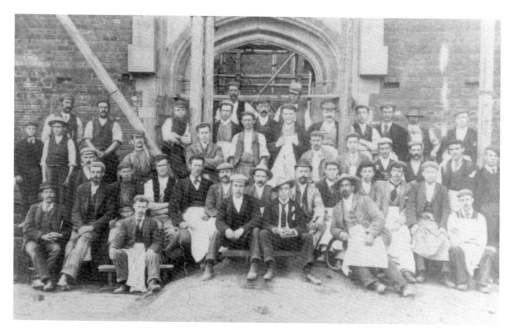

WORKMEN ENGAGED IN BUILDING HAWKESYARD PRIORY, Armitage, 1896. Henry James (second from left, back row) lost the sight of one eye during the building work.

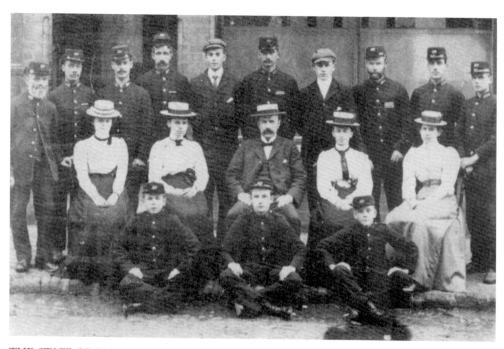

THE STAFF OF RUGELEY POST OFFICE in 1900. The post office was in a house in Market Street which had been the home of William Palmer, the notorious Rugeley Poisoner.

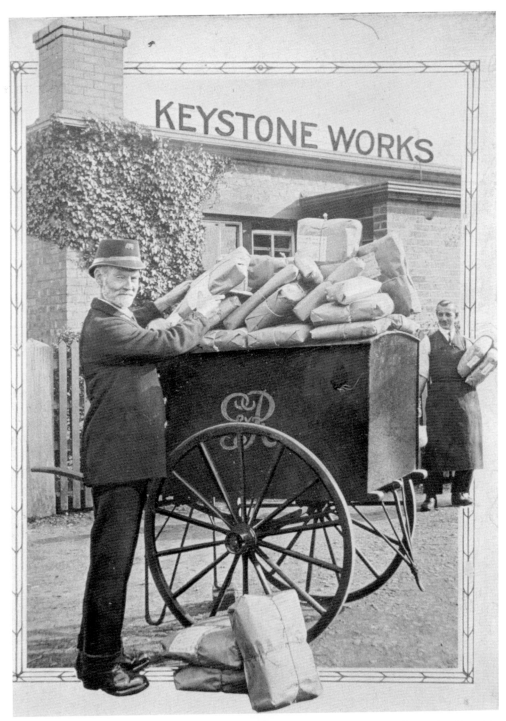

HENRY PARKER, a Rugeley postman, collecting parcels of tailored goods from the Keystone Works in the 1920s. Mr Parker, a quiet man, was always known as 'Silent Henry'.

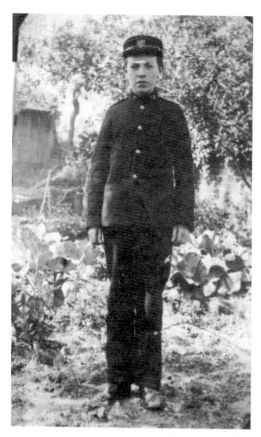

TOM PARKER, Henry's son, was a telegraph boy in 1903–4.

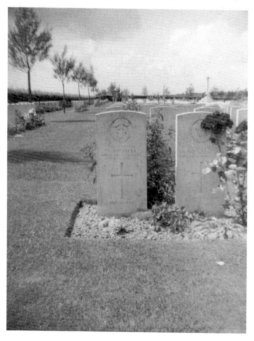

TOM WAS KILLED ON THE SOMME by a sniper's bullet in the First World War. This is a photograph of his grave.

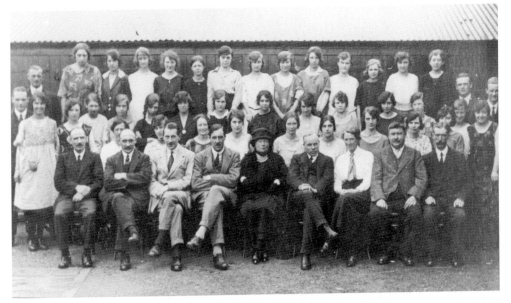

THE STAFF OF KEYS TAILORING FACTORY in 1925.

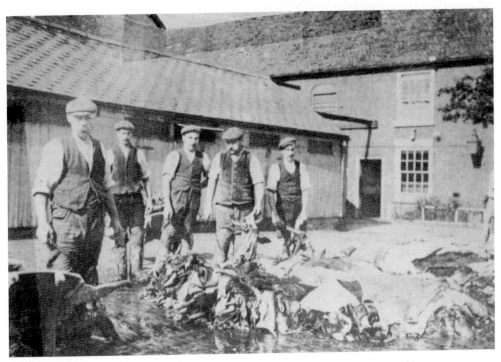

THE PHOENIX TANNERY, Rugeley, *c.* 1900. The skins are soaking in vats of brine.

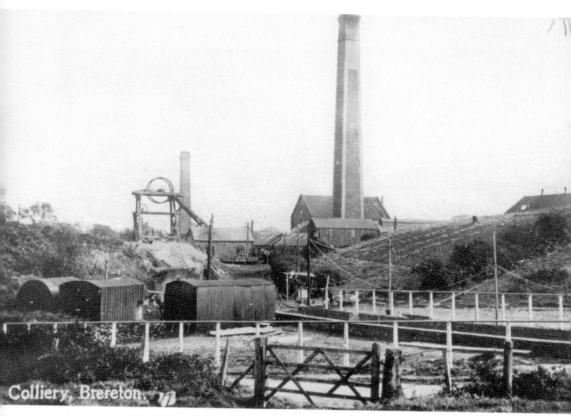

Colliery, Brereton.

THE HAYES COLLIERY, Brereton, *c.* 1905. This colliery was opened by the Marquis of Anglesey in 1817 and during the first half of the nineteenth century attracted many Irish miners to Brereton. It was closed during the 1950s. Set in the beauties of Cannock Chase, the scars left by the pit are gradually growing over and returning to wild countryside.

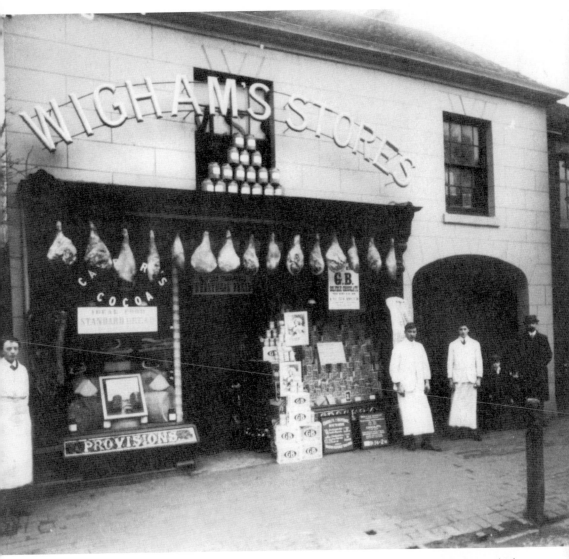

WIGHAM'S GROCERS SHOP, 29 Horsefair, Rugeley in 1912, Note the posts outside to which the horses were tied during the Horse Fair. The pavement was made of Staffordshire blue bricks.

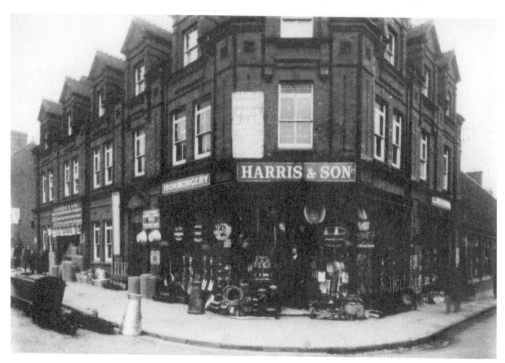

HARRIS & SON, Ironmongers, on the corner of Market Street and Market Square, Rugeley, in 1912. The shop was established in the mid nineteenth century and then took over Woodruffe's Albion Foundry. The garden rollers made by Harris' were sold to the big London stores like Selfridges and Harrods.

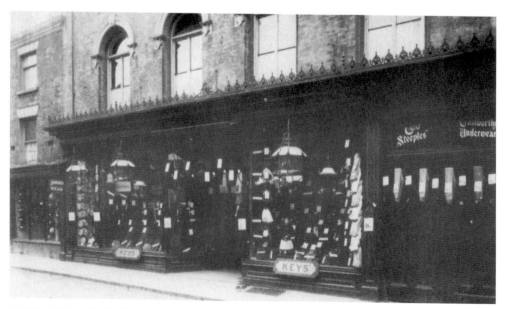

JOHN KEY AND SON, Drapers and Tailors, 8–10 Lower Brook Street, Rugeley.

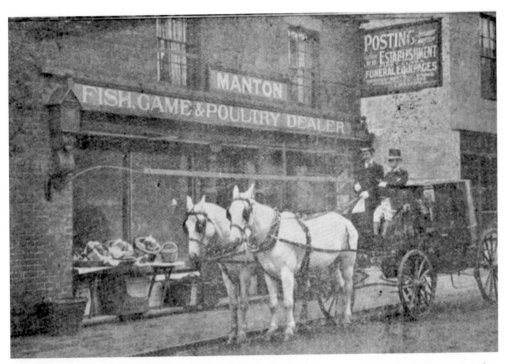

MR MANTON ran a posting establishment behind his fish, game and poultry shop in Market Street, Rugeley. This photograph was taken around 1895.

SHOPS AT THE TOP OF NEW ROAD, Armitage, 1910.

THE HIGH HOUSE, Colton, which housed the village shop, decorated for the Jubilee in 1897.

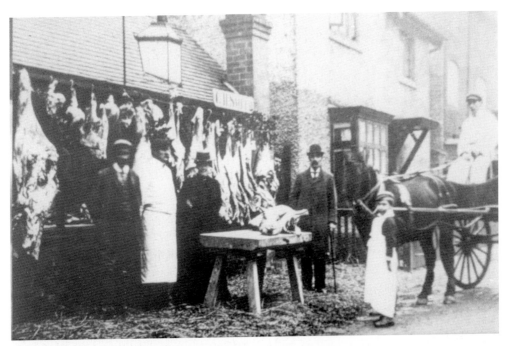

C.H. SMITH, Butcher, Meadow Lane, Little Haywood, *c.* 1908.

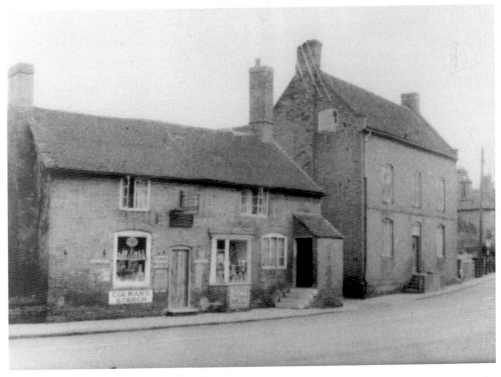

GROCERS STORE in Great Haywood, *c.* 1930.

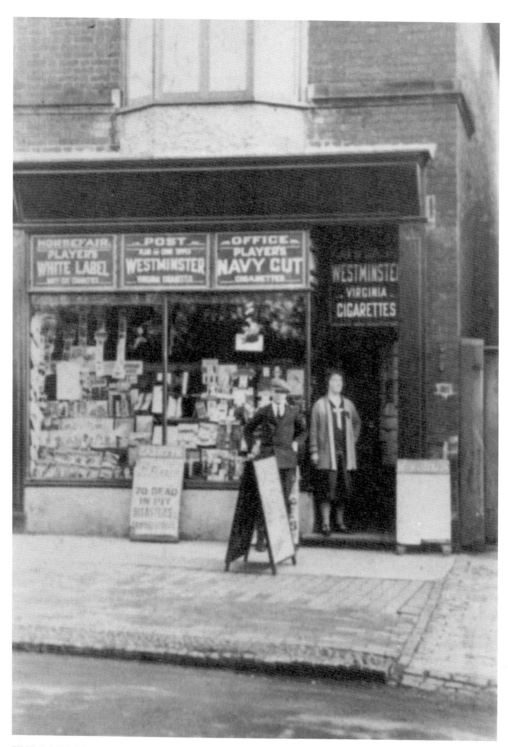

THE POST OFFICE IN HORSEFAIR, Rugeley, *c.* 1920.

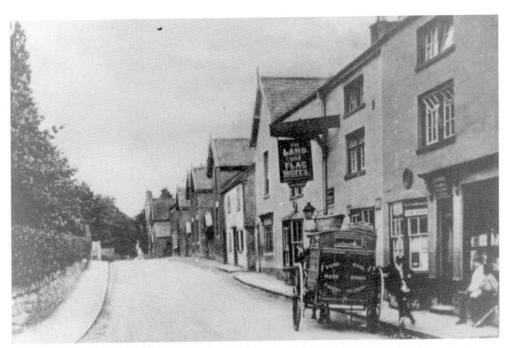

HORSE-DRAWN BREAD VAN outside the bakery and post office in Little Haywood. The bakery stopped baking in August 1949; it is now the newsagent's shop.

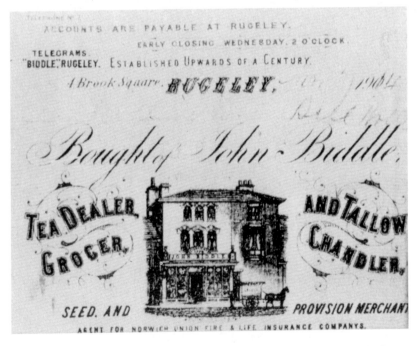

BIDDLES GROCERS SHOP was in Brook Square, Rugeley, and was established c. 1770. The billhead was printed in blue and red on pink paper.

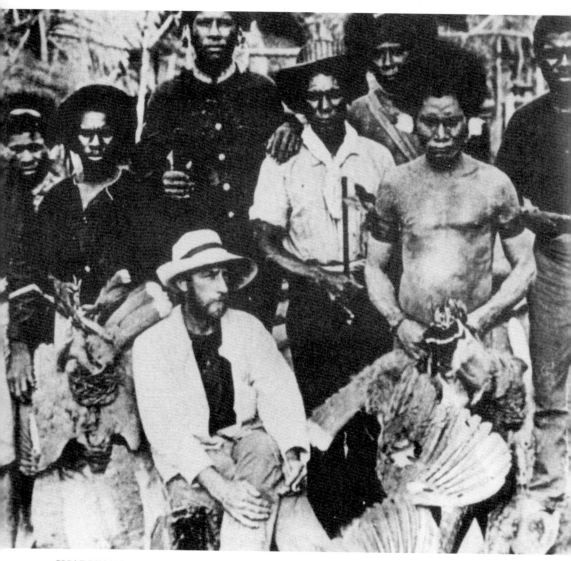

CHARLES BONNEY was the brother of H. T. Bonney, Headmaster of Rugeley Grammar School. When he was 21 Charles went to Sydney, Australia. He became the first man to 'overland' sheep, moving 10,000 of them vast distances across unexplored areas. He pioneered many new routes for overlanding cattle.

FREDERIC BONNEY was the nephew of
Charles Bonney. He lived in Colton Hall and
was responsible for the many photographs
which survive of Colton schoolchildren
on May Day. When he moved to Church
Street in Rugeley, he would invite local
schoolchildren to visit with their teacher to
see his garden, and the birds he tamed. He
always had a pocketful of bird seed.

THE HON. WILLIAM BAGOT of Blithfield
in his Staffordshire Yeomanry uniform,
c. 1860. He was born in 1851.

REVD TT. WORTHINGTON, Rector of Fradswell, and his horse 'Fairies' outside Fradswell Rectory.

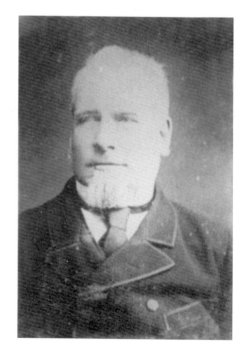

EDWARD JOHNS, the founder of Edward Johns and Co., Sanitary Pottery, which later became Armitage Shanks.

MISS LUCY E. LANDOR, and her maid Ellen, *c.* 1895.

WILMOT MARTIN OF HIXON ran a concert party to raise funds for charity. He obtained permission from Harry Lauder to sing his signature tune 'Keep right on to the end of the road'. This picture shows Wilmot with Harry Lauder.

THE SUM TOTAL OF THE AGES OF THESE HIXON VILLAGERS added up to 502 in 1934. They are seen outside the post office, now demolished.

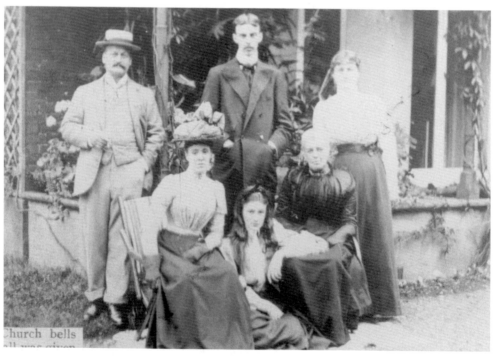

MR & MRS GARDINER and their family of The Towers in Armitage.

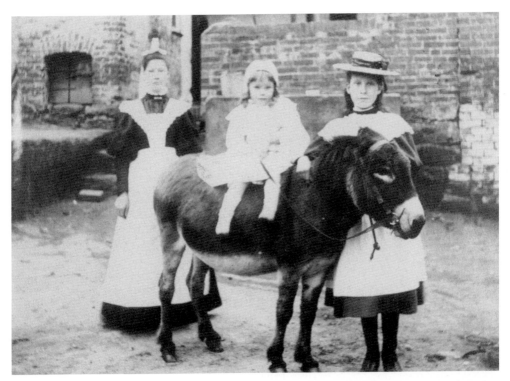

FAMILY GROUP OUTSIDE ROCKHOUSE FARM, Great Haywood, before 1905. The farm has disappeared under new housing.

RUGELEY'S LAST TOWN CRIER, MR GEORGE UPTON. He would cry 'God save the Queen (Victoria) and the Lord of the Manor (Marquis of Anglesey)' before calling out the news. He is holding a £5 note and a walking stick which he won for entering the lion's cage at a circus.

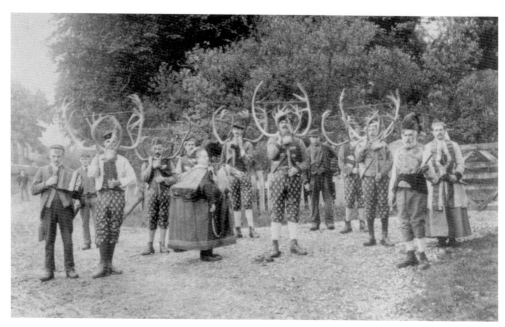

THE ABBOTS BROMLEY HORN DANCE, 1899. The Horn Dance is performed annually on the first Monday after the first Sunday after 4 September. The horns, which are reindeer horns, are kept in Abbots Bromley Church.

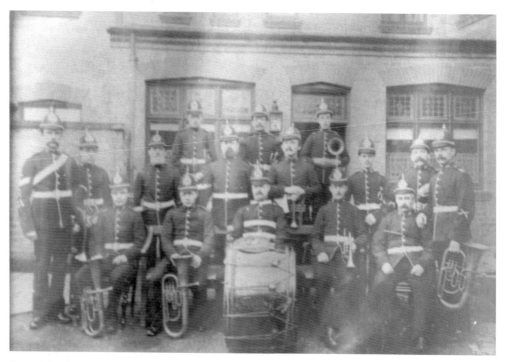

21ST CO. RIFLE VOLUNTEERS at Rugeley in the 1890s.

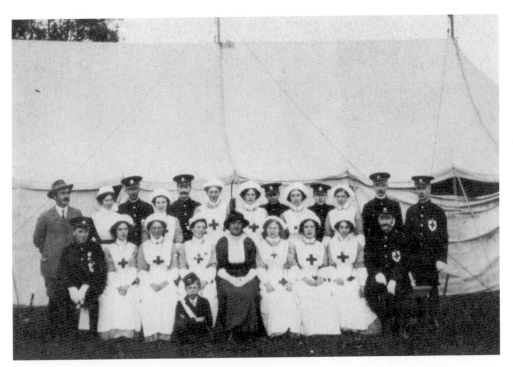

ST JOHN'S AMBULANCE BRIGADE at Armitage in 1910.

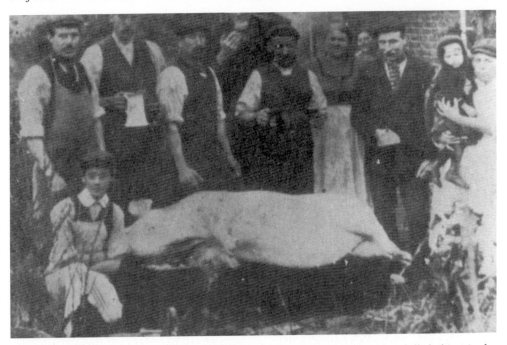

THE SMITH FAMILY of the Basin cottages in Armitage Road, Rugeley, killed this pig for Christmas, 1910.

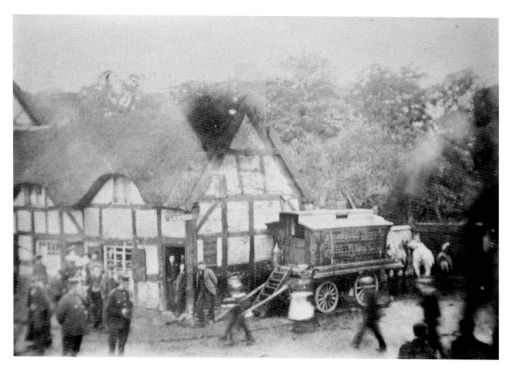

GYPSY CARAVAN with its occupants in Horsefair, Rugeley, 1890.

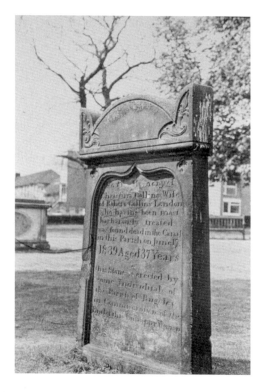

THE GRAVE OF CHRISTINA COLLINS in Rugeley churchyard. In 1839 she was found murdered in the canal near Rugeley aqueduct. The steps down which she was supposedly dragged are still known locally as the Bloody Steps. Three boatmen were convicted for her murder.

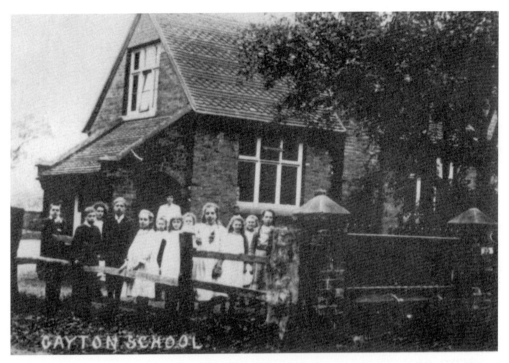

CHILDREN OUTSIDE GAYTON PUBLIC ELEMENTARY SCHOOL, 1910. The school was built in 1870 at the expense of the Earl of Harrowby.

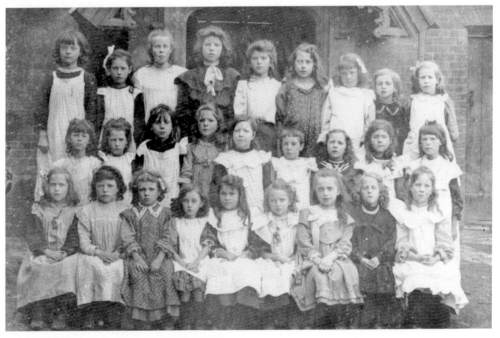

GIRLS' CLASS AT ARMITAGE SCHOOL, *c.* 1906.

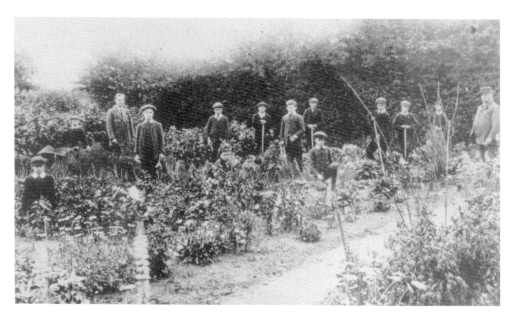

ARMITAGE SCHOOL boys' gardening class, 1914.

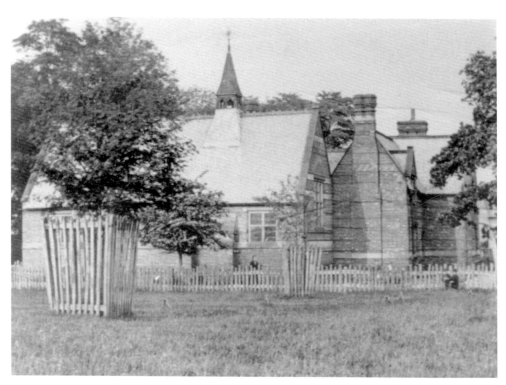

BLITHFIELD VILLAGE SCHOOL, 1890. The school was built in 1857 as a memorial to the second Lord Bagot.

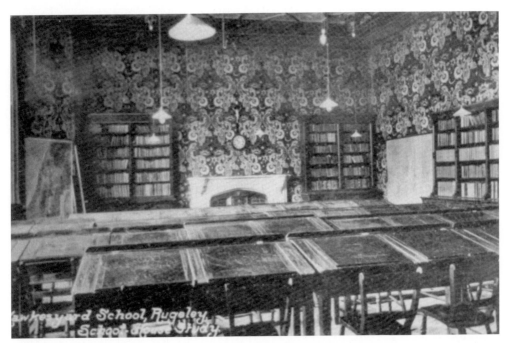

STUDY IN THE SCHOOLHOUSE of Hawkesyard Roman Catholic Preparatory School in Armitage.

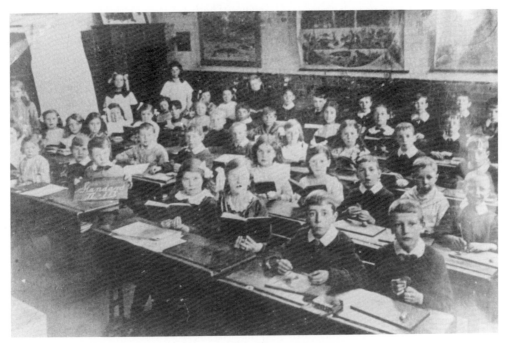

STANDARDS I AND II of St Joseph's Catholic School, Rugeley.

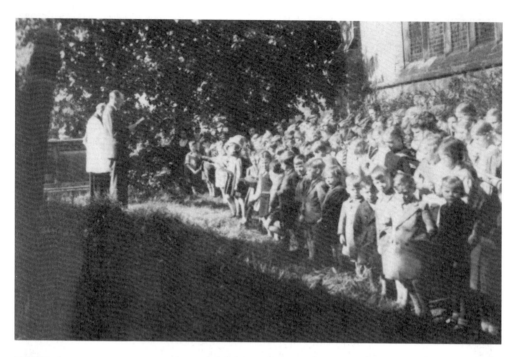

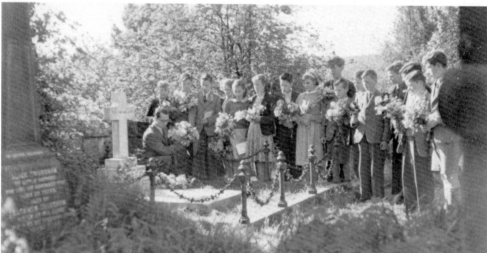

ANNUAL SERVICE HELD IN COLWICH CHURCH GRAVEYARD on 13 May and attended by the children of Colwich school to commemorate the birthday of Charlotte Sparrow of Bishton, who founded the school. The first reference to this is in 1879, five years after Miss Sparrow died. These photographs were taken in the 1950s but in 1892 this is how this touching ceremony was described: 'Today is Miss Sparrow's birthday. Instead of the usual afternoon school, the children assembled at two o'clock, marched across to the churchyard where the vicar met them and gave them a short address. After singing two hymns at Miss Sparrow's grave, the children decorated the grave with primroses, cowslips, pansies and other flowers.' The tradition of decorating the grave goes on today.

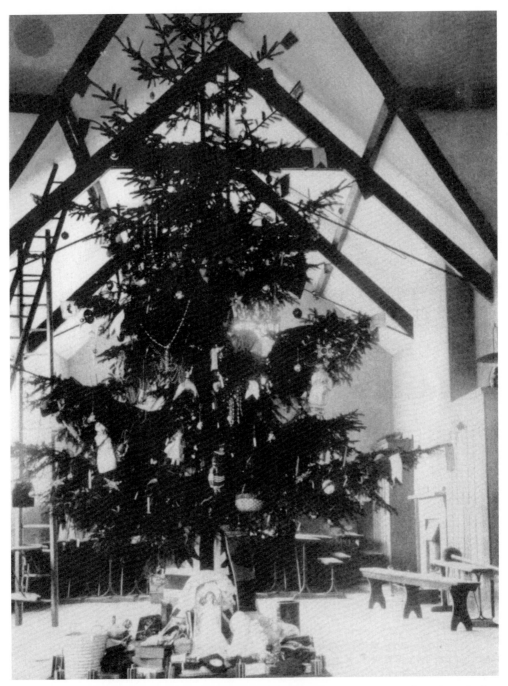

CHRISTMAS TREE at Colton's St Mary's School, *c.* 1900. The vicar's sisters, the Misses Parker, provided all the presents for the schoolchildren. The school only had a tree once every three years because it took this long for the ladies to hand sew all the clothes for the dolls which they gave to the girls. The boys had penknives.

THE CHURCH OF ST JOHN THE BAPTIST, Armitage *c.* 1880.

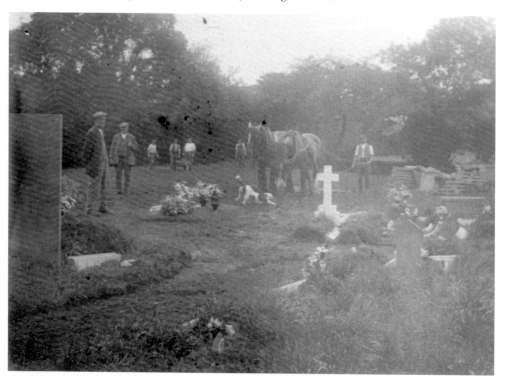

LEVELLING THE CHURCHYARD in Armitage in 1926.

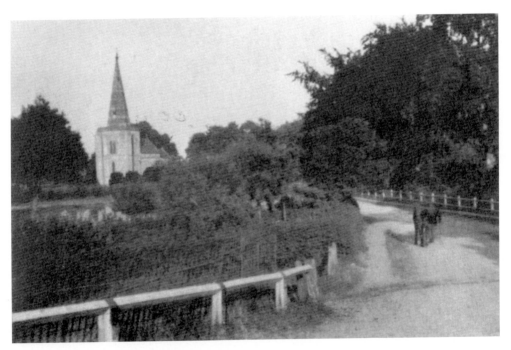

ST ANDREW'S CHURCH, Weston, *c.* 1910.

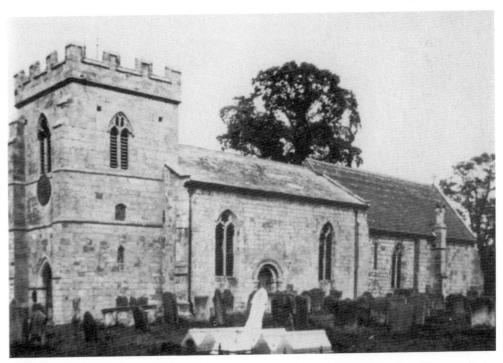

THE CHURCH OF ST JOHN THE BAPTIST, Stowe-by-Chartley, which dates from Norman times.

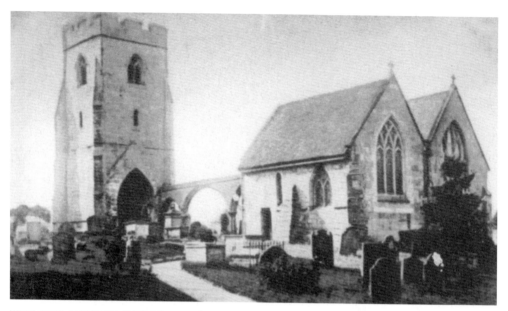

THE OLD CHURCH IN RUGELEY became so unsafe by 1817 that it was decided to replace it with a new building across the road. The walls of the old church were blown up with gunpowder and the stones used to build the new church wall. It is now known as the Old Chancel.

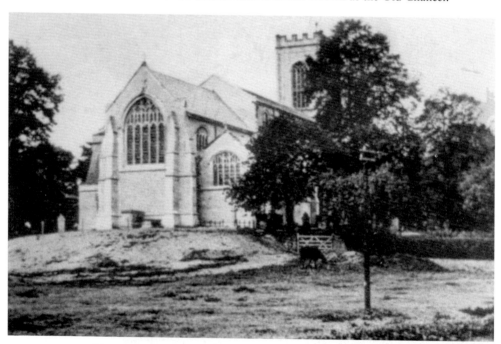

ST AUGUSTINE'S CHURCH, Rugeley, built in 1822, replaced the Old Chancel. In the churchyard are buried two murder victims: Christina Collins lost her life on the canal nearby, and John Parsons Cook was a victim of William Palmer, the poisoner.

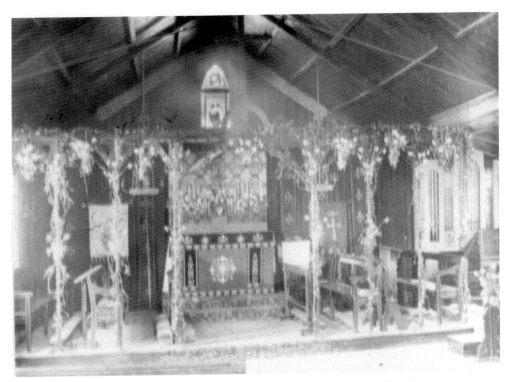

INTERIOR OF ST MARY'S CE MISSION in Horsefair, Rugeley, now pulled down.

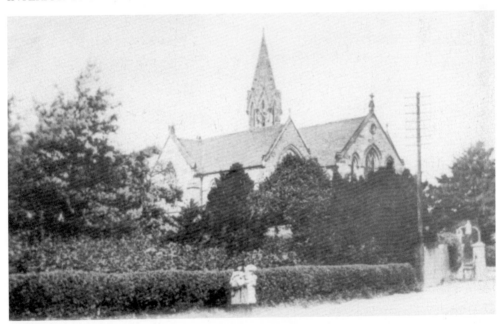

ST MICHAEL'S, BRERETON. Designed in 1837 by Thomas Trubshawe, a local architect, but later enlarged by Sir Gilbert Scott.

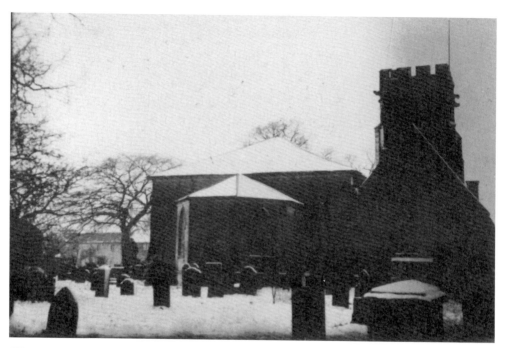

ST NICHOLAS, MAVESYN RIDWARE in the 1950s, It is notable for the Mavesyn Chapel, in which the Mavesyn family monuments are assembled and the family's exploits celebrated in alabaster panels.

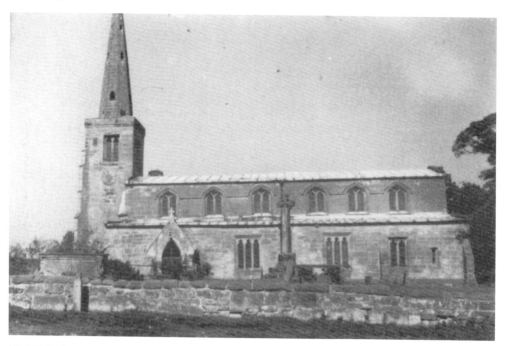

ST MICHAEL'S CHURCH, Hamstall Ridware.

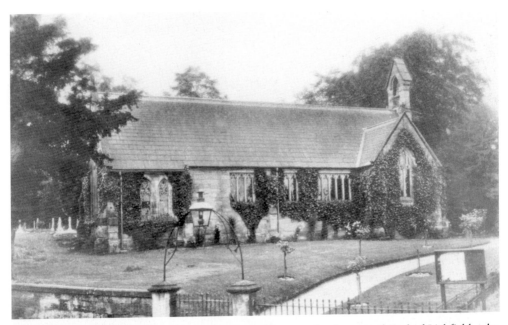

ST STEPHEN'S, Great Haywood, *c.* 1925, erected in 1840 by the second Earl of Lichfield, who is buried here. It was designed by Thomas Trubshawe, one of Haywood's architectural dynasty. The creeper on the walls has since been removed.

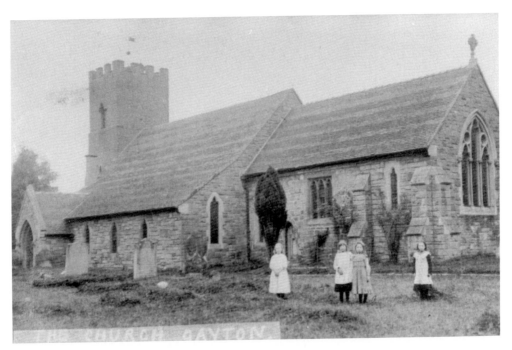

ST PETER'S CHURCH, Gayton, 1903.

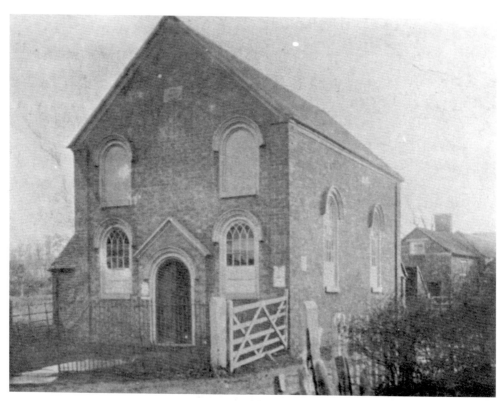

HIXON METHODIST CHAPEL, *c.* 1900.

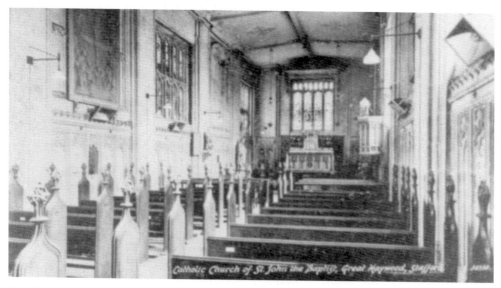

ST JOHN'S ROMAN CATHOLIC CHURCH, Great Haywood. The church was originally built by Joseph Ireland in nearby Tixall in 1828, but was taken down and re-erected in Great Haywood in 1845. It is still possible to see the numbers on some of the stones.

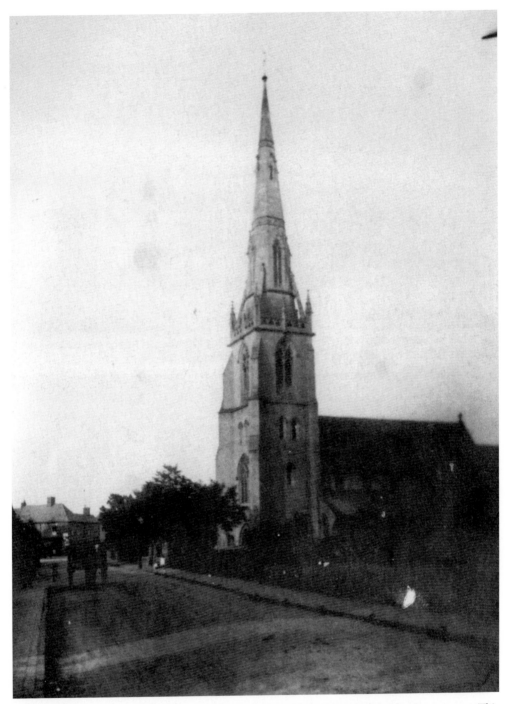

ST JOSEPH AND ST ETHELREDA'S ROMAN CATHOLIC CHURCH, Rugeley, *c.* 1905. This church was built by Charles Hansom, the brother of the inventor of the Hansom cab. The spire was added later and the east window is by Pugin.

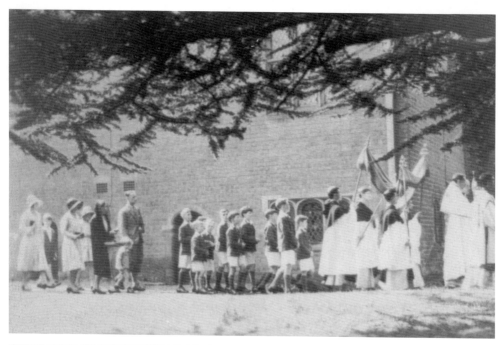

CEREMONY IN HAWKESYARD PRIORY in the late 1920s. This Dominican Priory was built between 1896 and 1914. The boys were from the preparatory school at the priory.

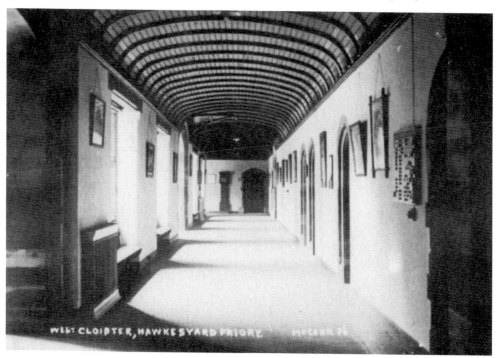

THE CLOISTERS at Hawkesyard Priory, *c.* 1905.

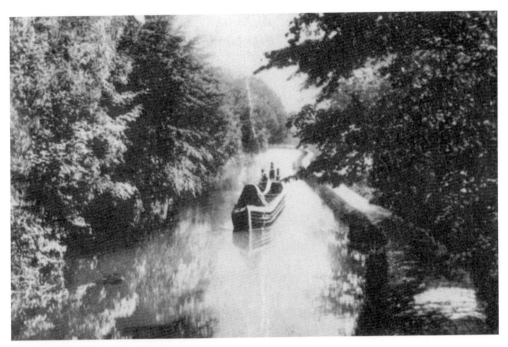

ON THE TRENT AND MERSEY CANAL at Great Haywood, *c.* 1910.

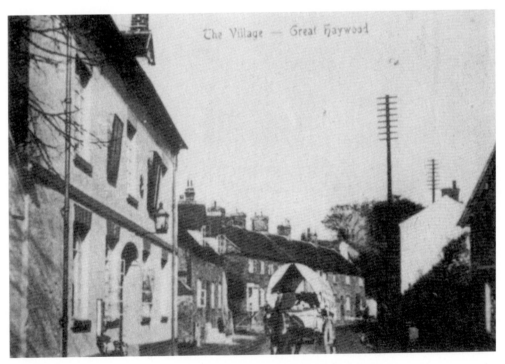

The Village — Great Haywood

DELIVERY CART outside the Clifford Arms in Great Haywood, *c.* 1905.

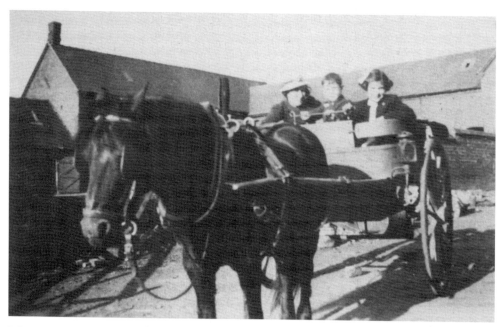

PONY AND TRAP AT MANOR FARM, Colton, in the 1940s. Jesse the pony ferried people to and from the Trent Valley station. In the '30s Jesse had to ford the River Blythe before the bridge was built.

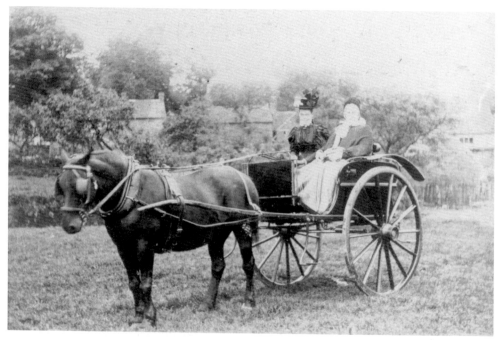

MRS TURNOCK AND HER DAUGHTER in Great Haywood. This photograph was taken *c.* 1905 on the site of what is now Tylecote Crescent.

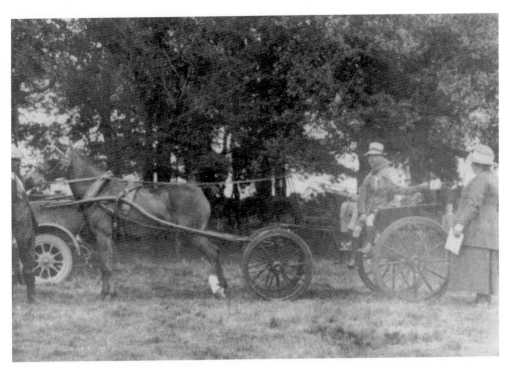

DRIVING TURNOUT on the Cliffs at the Haywood Show, *c. 1924–5.*

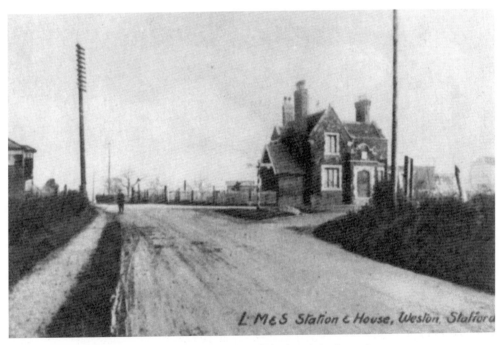

L·M&S Station & House, Weston, Stafford

WESTON STATION on the LMS line, now demolished and the line taken up.

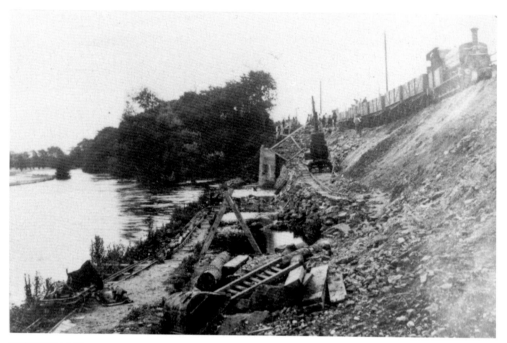

WIDENING THE RAILWAY near the bridge at Armitage, 1910–1912. The workmen were itinerent Irishmen. Miss Dorothy Parker of The Towers, Armitage, arranged food and accommodation for them in the small Wesleyan chapel.

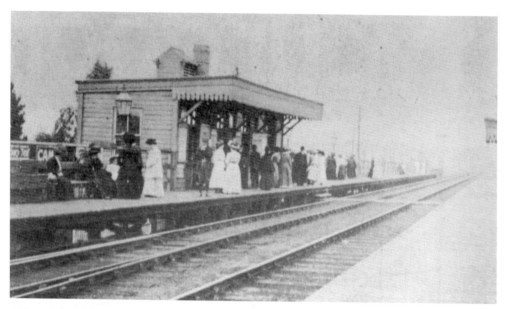

Although faded, this is one of the earliest photographs of RUGELEY TOWN STATION. A line to link the Trent Valley Railway with the Cannock and Walsall line was built in 1859 to carry coal from the coal pits but this station was not built until July 1870. It was closed in 1965.

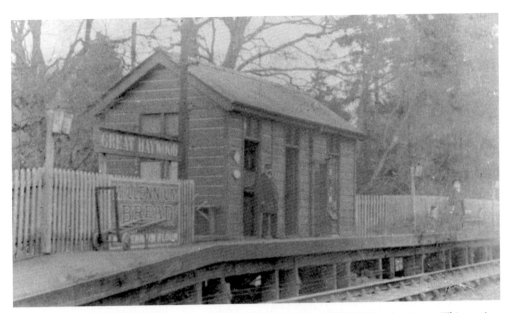

THIS IS A RARE PHOTOGRAPH OF GREAT HAYWOOD STATION in the 1890s. This station on the Trent Valley line was originally for the use of the Earl of Lichfield at nearby Shugborough Hall. Subsequently it became a halt and was closed finally after the Second World War.

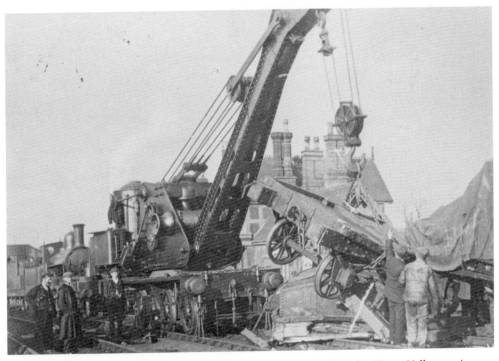

SALVAGE WORK FOLLOWING A TRAIN COLLISION at Rugeley Trent Valley station on 12 November 1905.

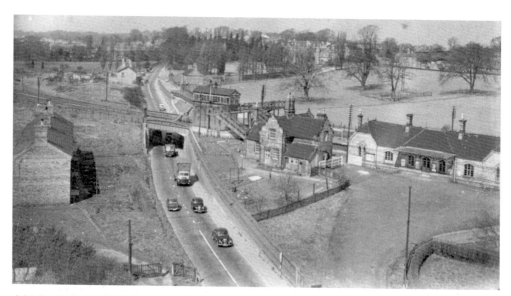

COLWICH JUNCTION from the church tower in 1956. This was the scene of the 1986 Colwich train disaster.

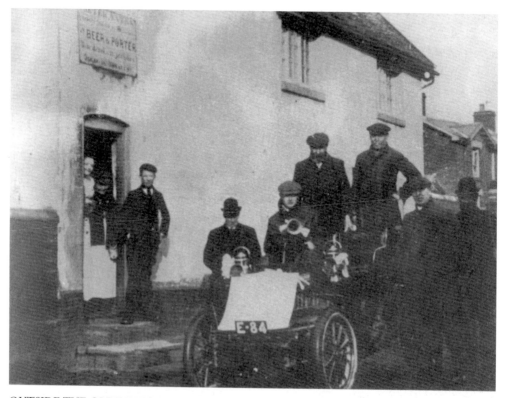

OUTSIDE THE OLDE DUN COW, Colton. The registration letter E was the first series to be used in Staffordshire.

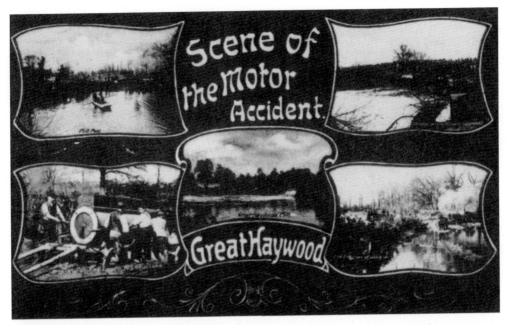

MOTOR ACCIDENT AT THE MILL, Great Haywood, 9 March 1905, in which two women died. This attracted such interest locally that several different postcards were made of it. The road was diverted and a new bridge built, but not until 1936.

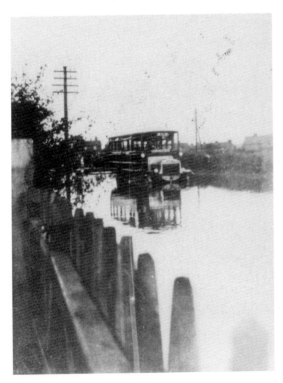

IN HEAVY RAIN *c.* 1925 ARMITAGE ROAD FLOODED BADLY and this local bus became stranded. It was eventually pushed out by men who lived nearby.

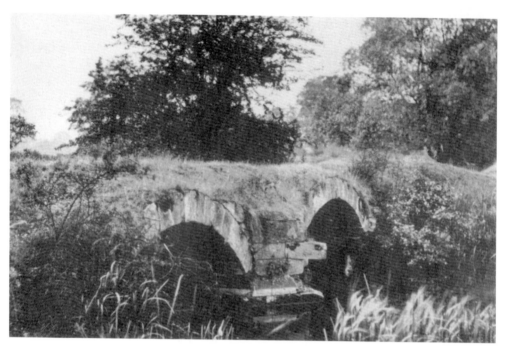

THE OLD TRENT BRIDGE at Handsacre.

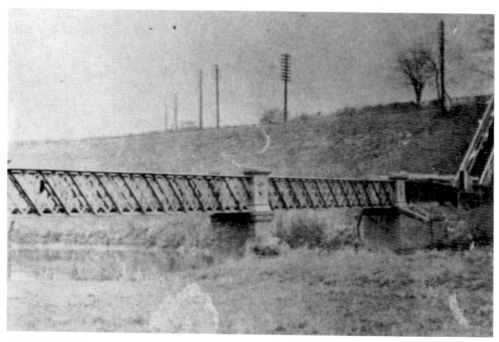

THE BRIDGE OVER THE RIVER TRENT at Armitage. The steps leading up to and over the railway were considered too dangerous and a tunnel was made beneath the railway line.

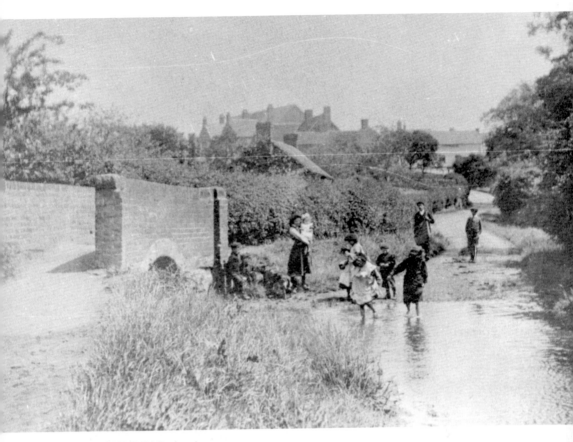

THE FORD, OLD ROAD, Armitage, *c.* 1900.

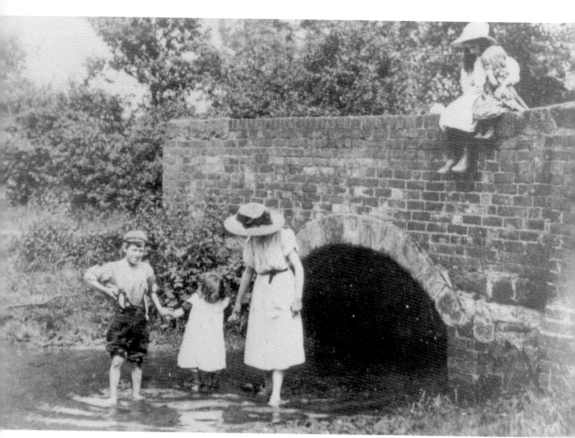

ANOTHER VIEW of the Ford, Old Road, Armitage.

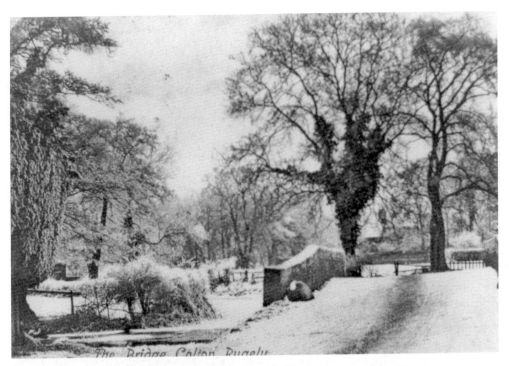

THE BRIDGE AT COLTON, a wintry scene around 1900.

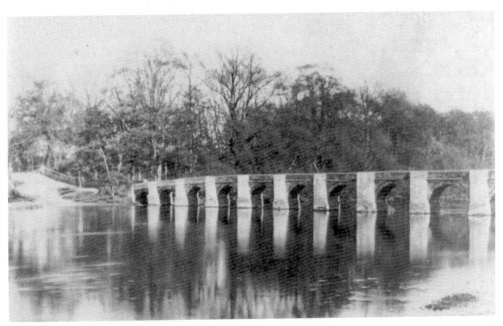

ESSEX BRIDGE, GREAT HAYWOOD, 1863. This was one of a series of photographs of Shugborough and its surroundings by William Warren Vernon.

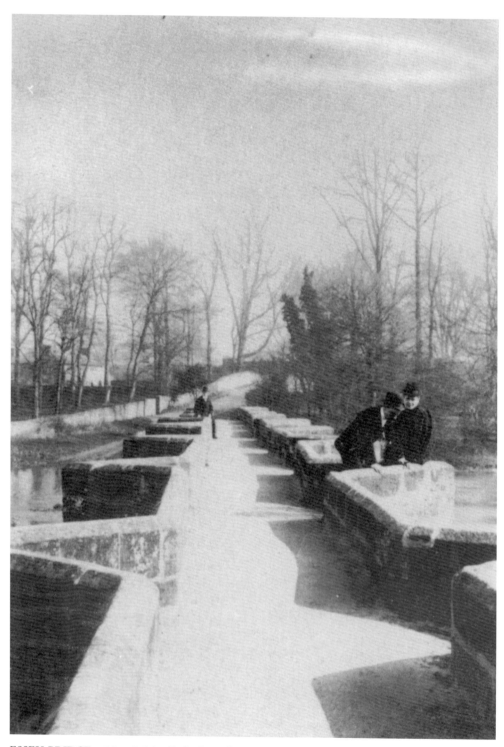

ESSEX BRIDGE, 1880. Originally built in the sixteenth century, it is only four feet wide.

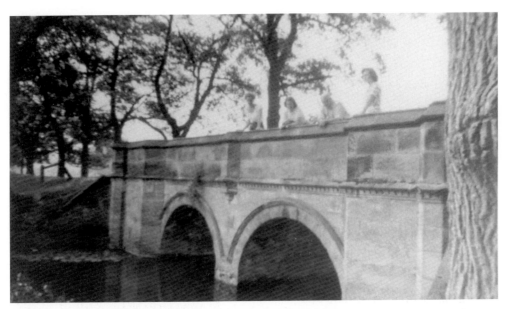

KITTY FISHER'S BRIDGE over the River Blythe at Blithfield in the late 1940s. The bridge was lost from view by the flooding of the area to make Blithfield Reservoir in 1953.

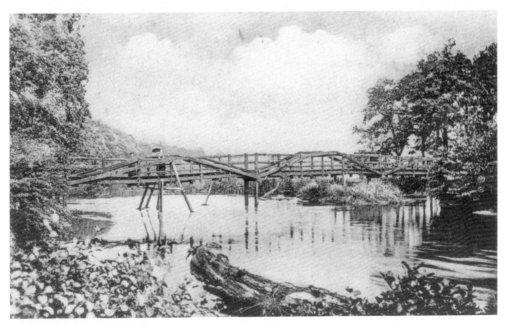

THE OLD WOODEN BRIDGE AT MEADOW LANE, Little Haywood. This photograph was taken before 1887/8, when it was replaced by the present bridge, paid for by public subscription and the generosity of Joseph Weetman. Hence the new bridge is called Weetman's Bridge.

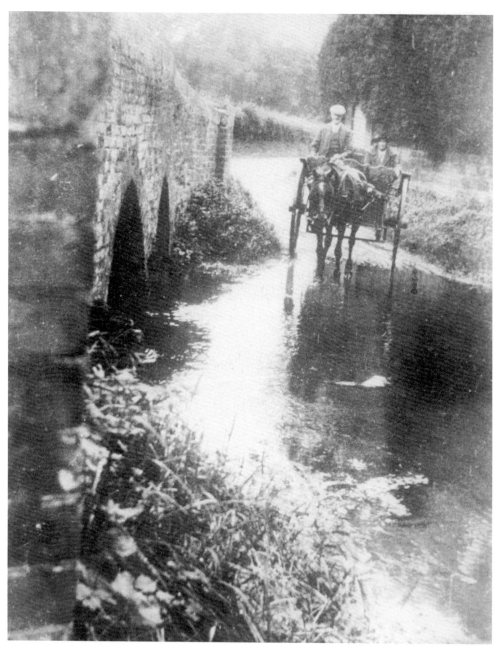

MR & MRS JIM CARR going through the ford at Colton Brook Bridge, *c.* 1925.

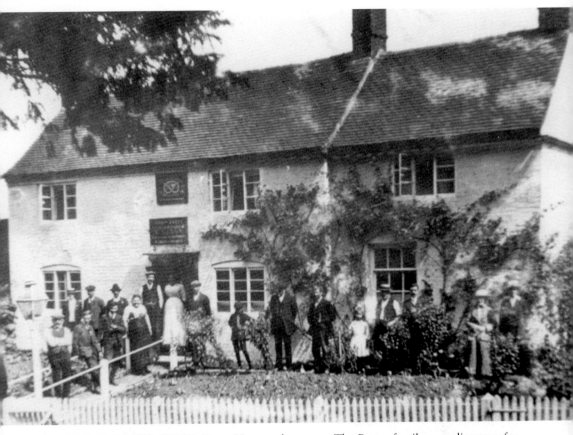

THE STAFFORDSHIRE KNOT, Great Haywood *c.* 1910. The Potter family were licensees for at least sixty years.

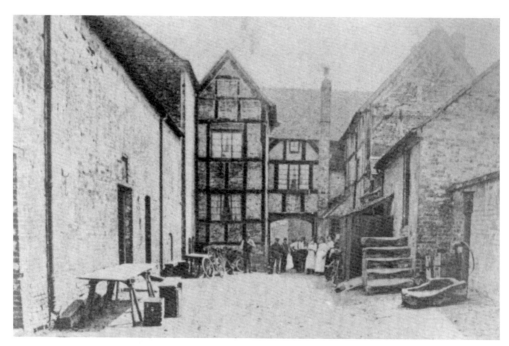

THE ORIGINAL CLIFFORD ARMS HOTEL, Great Haywood. In 1930, this was demolished and the present hotel built.

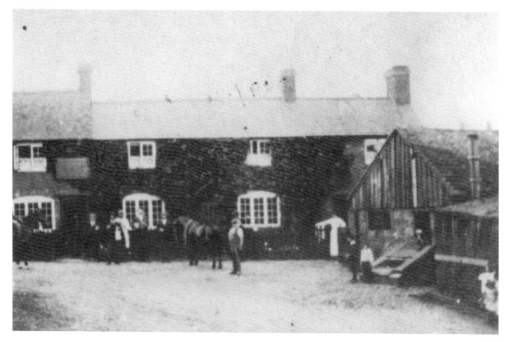

THE NAVIGATION INN by the canal in Little Haywood, *c.* 1910. It had ceased to be a public house by 1916 and after the First World War became a farm.

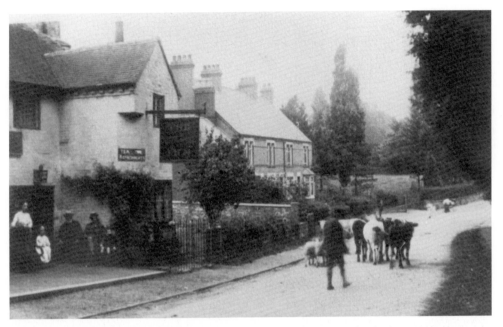

THE OLD RED LION at Little Haywood, *c.* 1910. Note the teas and refreshments sign.

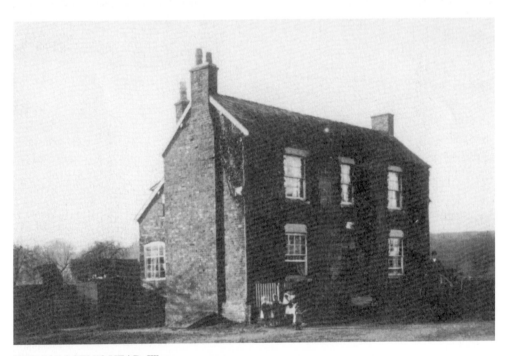

THE SARACEN'S HEAD, Weston, *c.* 1912.

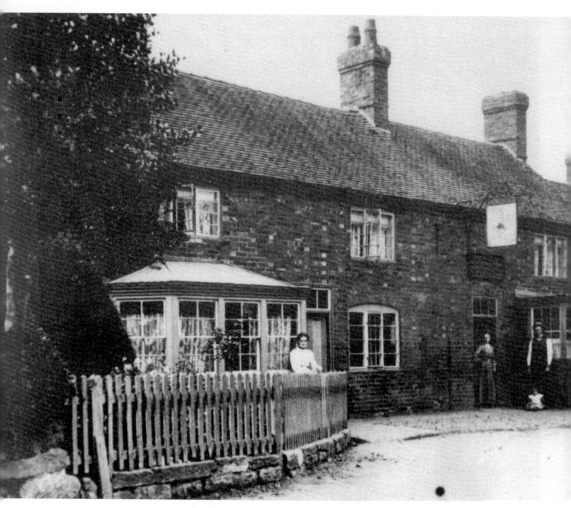

THE COCK INN, Stowe-by-Chartley, *c.* 1912. The licensee was Owen Evans.

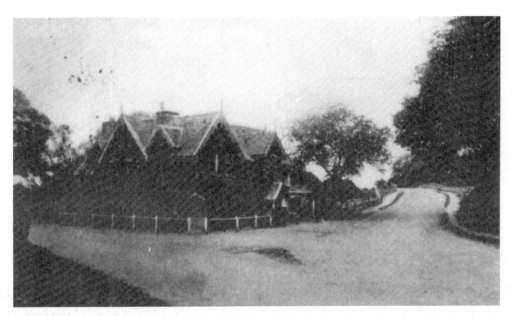

THE ROEBUCK INN, Wolseley Bridge, now called the Wolseley Arms. The original Roebuck was on the other side of the road (now a restaurant) and, when this was closed in the early nineteenth century, the Wolseley Arms 'borrowed' its name. Owing to its position at the junction of the London, Liverpool and Holyhead road, it was an important coaching and posting house.

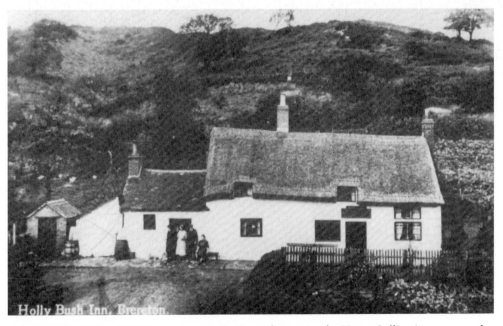

THE HOLLY BUSH INN, Brereton, c. 1918. Situated opposite the Hayes Collier; it was a popular port of call for miners coming off shift. During the Second World War, American soldiers were fascinated by its old world charm. It is now a private home.

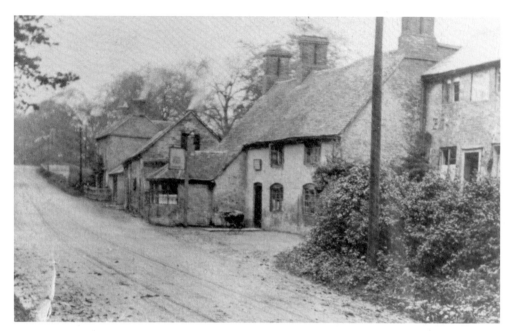

THE OLD PLUM PUDDING at Armitage, 1900.

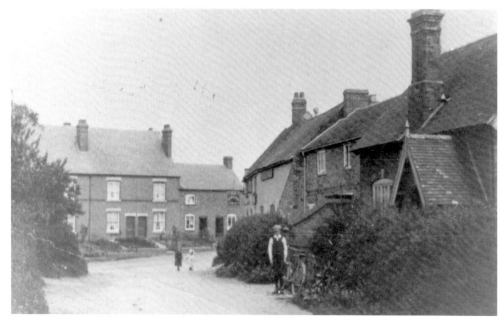

THE RED LION, Handsacre. Part of this pub dates from 1794.

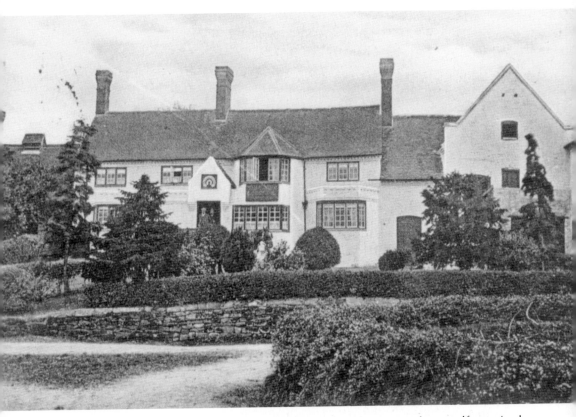

THE BANK HOUSE, Hixon. The buildings adjacent to the pub were used as a self-contained brewery.

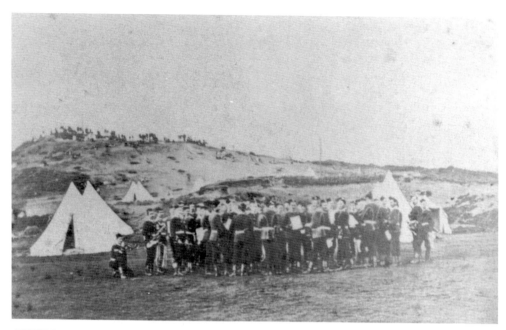

AUTUMN MANOEUVRES on Cannock Chase around 1873.

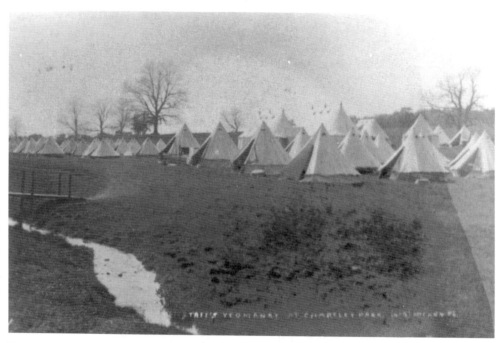

THE STAFFORDSHIRE YEOMANRY at camp in Chartley Park, *c.* 1910.

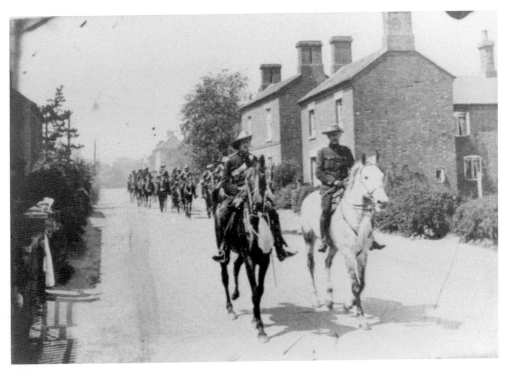

NEW ROAD, Armitage: cavalrymen setting off to, and returning from, the Boer War, 1899 and 1902.

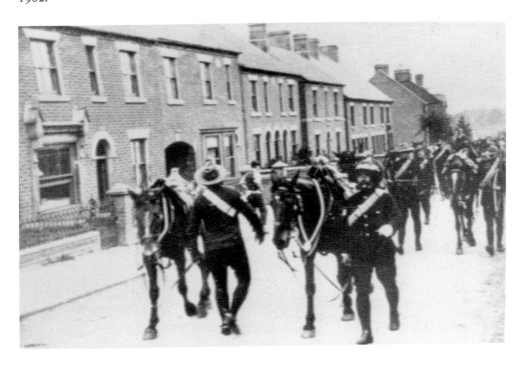

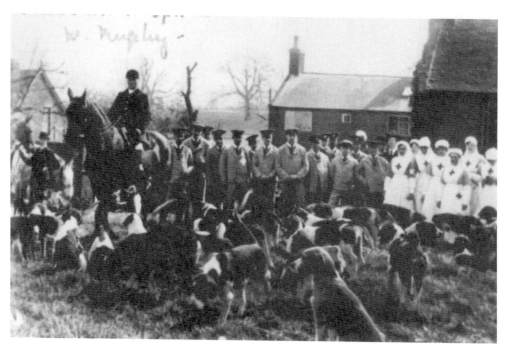

RAVENHILL HOUSE, Rugeley, was used as a military hospital during the First World War. This photograph shows some of the patients in their hospital blues watching the South Staffordshire Hunt.

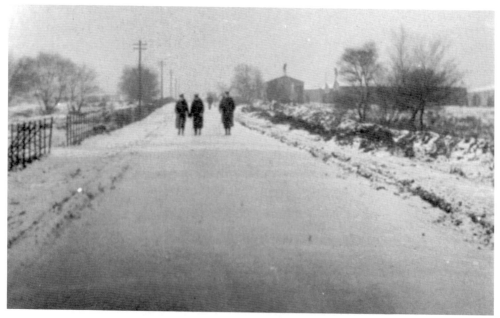

FIRST WORLD WAR SOLDIERS walking back from Rugeley to camp on Cannock Chase in the bleak midwinter. There were two army camps on the Chase at this time.

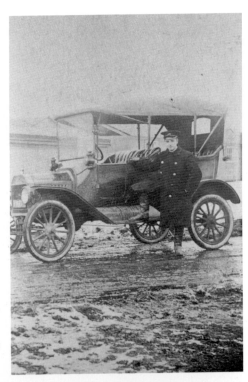

OFFICERS AT THE CHASE CAMPS used this taxi run by Degg's garage in Rugeley.

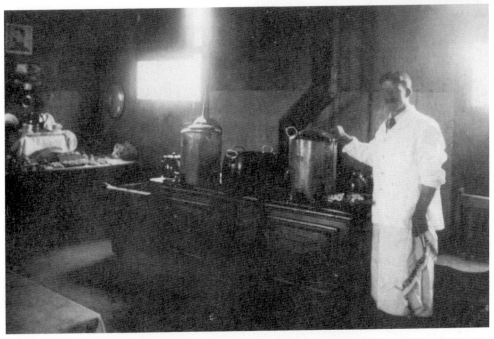

A KITCHEN AT RUGELEY CAMP, showing one of the two cooking stoves it contained. The urns probably heated water and the size of the pans indicates the scale of catering undertaken.

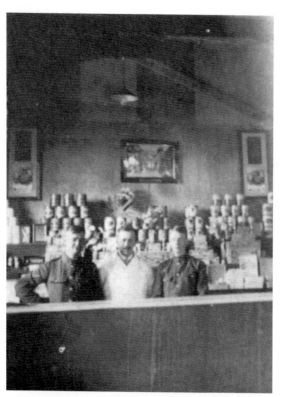

TWO VIEWS OF THE DRY
CANTEENS at Rugeley Camp, 1914–18.
If the soldiers could afford them, these
goods provided treats in a cold, cheerless
camp. Some of the brand names are still
familiar today.

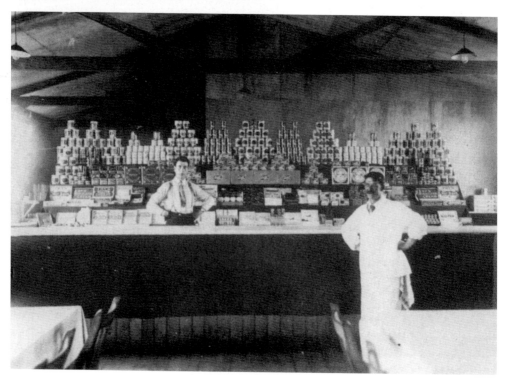

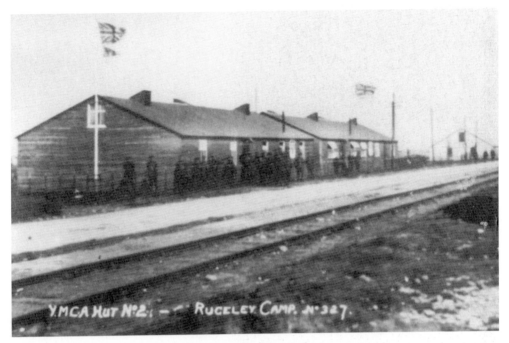

ONE OF THE YMCA HUTS on Rugeley camp, 1914–18.

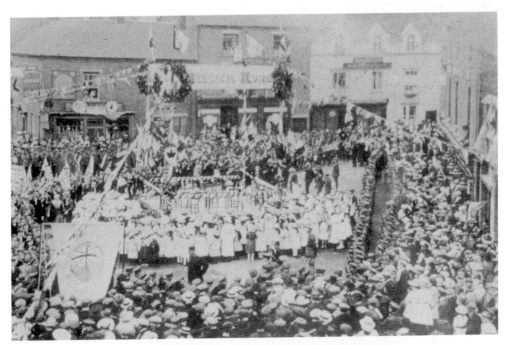

RUGELEY WELCOMES THE RETURNING TROOPS after the Great War.

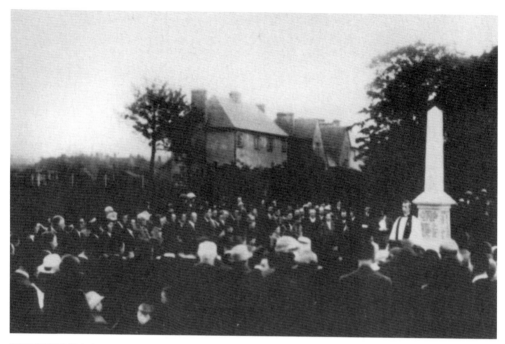

DEDICATION OF THE WAR MEMORIAL at Weston to the fallen of the First World War.

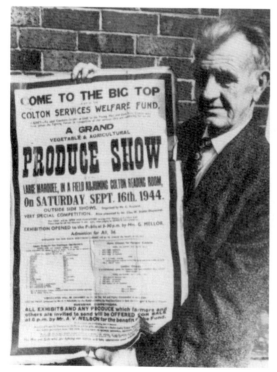

CHARLES ROBINSON, who organised activities like this in Colton to provide money and comforts for serving men and women from the village during the Second World War.

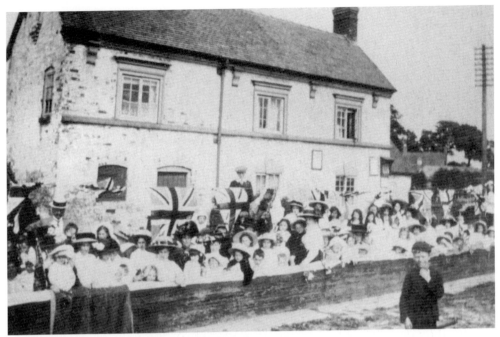

SUNDAY SCHOOL OUTING TO OAKEDGE along the Trent and Mersey canal from Rugeley, *c.* 1909. Such outings usually started from Rugeley Town Wharf near the tannery.

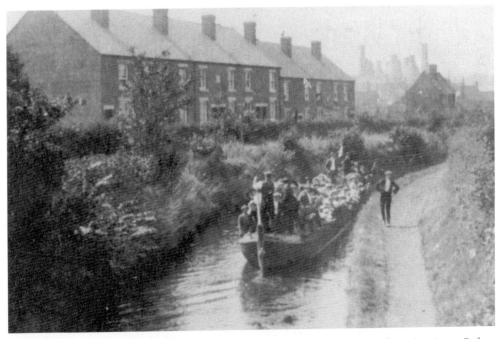

METHODIST CHILDREN'S OUTING by horse-drawn boat to Oakedge from Armitage. Before the outing these working barges had to be cleaned up ready for the children.

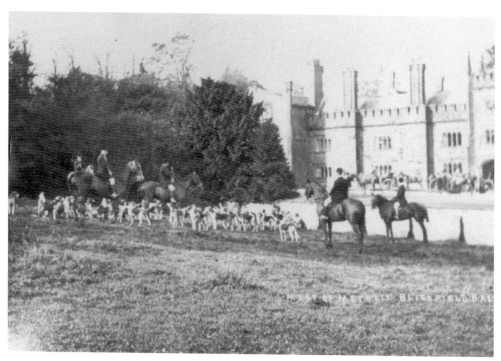

THE MEYNELL HUNT outside Blithfield Hall, *c.* 1912.

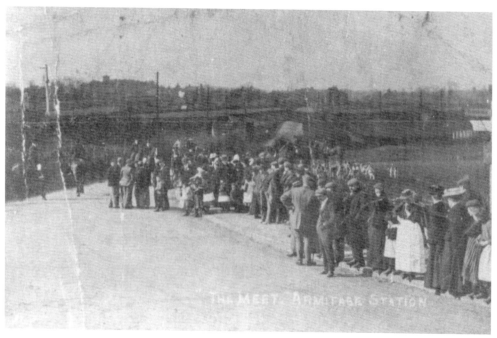

THE MEET, Armitage station, *c.* 1900.

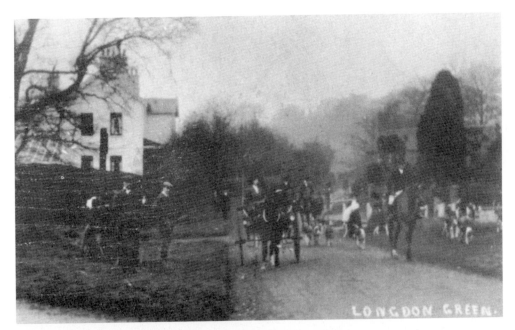

THE HUNT AT LONGDON GREEN, 1910.

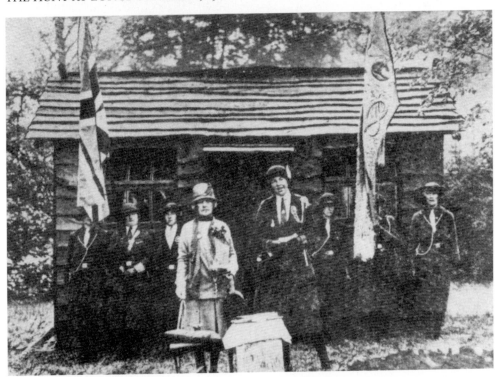

THIS 'SHIELING' OR SHELTER was erected for Girl Guides on their camping ground at Beaudesert, in 1929.

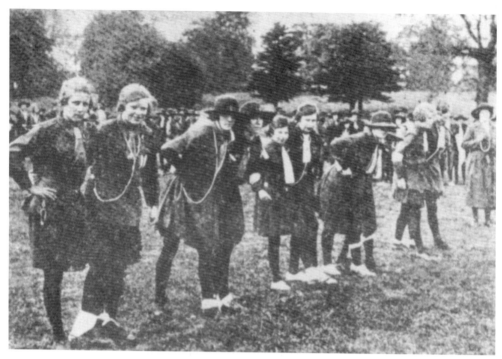

THE STAFFORD AND DISTRICT GIRL GUIDES ASSOCIATION held their annual competitions in the grounds of Bellamour Hall, Colton, in May 1928. Despite incessant rain, these girls are carrying on with the final of the three-legged race.

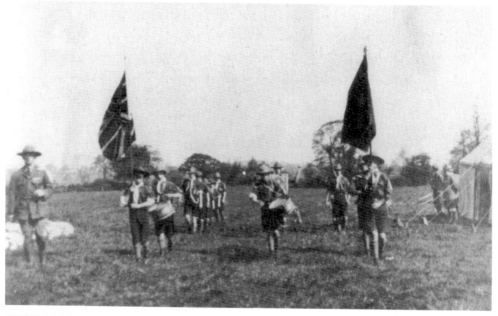

HIXON SCOUT TROUP AT CAMP, c. 1920. The Scoutmaster was Mr A. E. Anslow.

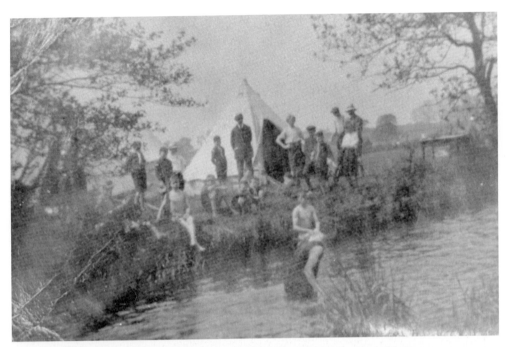

AT THE SAME CAMP, the Hixon scouts enjoyed swimming in the River Blythe.

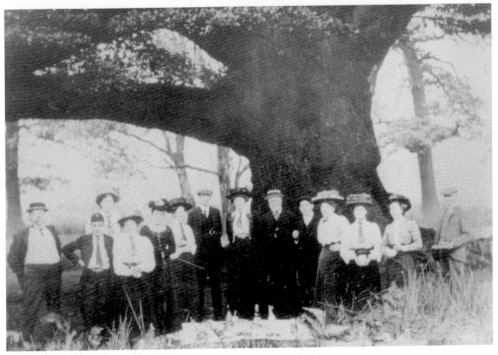

BLITHFIELD HALL SERVANTS pictured on their annual picnic under the Beggars Oak in Bagots Park, *c.* 1910.

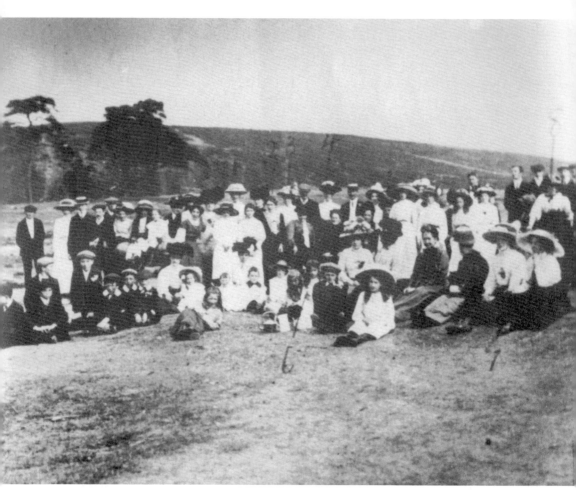

ST LUKE'S MISSION, Armitage, outing to Milford Common.

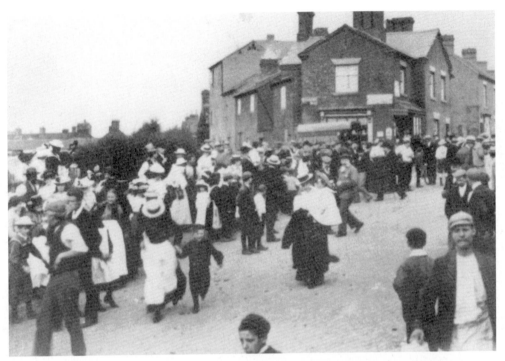

WALKING RACE organised by Armitage Club and Institute, July 1903. The route went from Armitage via the bridges at Rugeley to the Whittington Inn, Lichfield, and then back to Armitage.

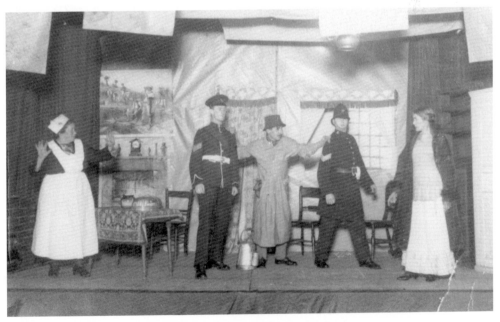

GREAT HAYWOOD AMATEUR DRAMATIC SOCIETY production, c. 1925.

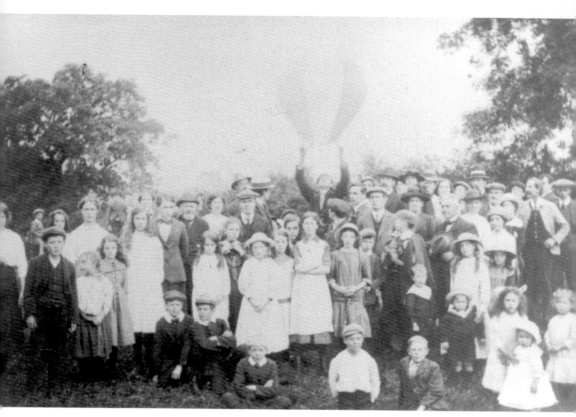

EXTRACT FROM *ARMITAGE PARISH MAGAZINE*, 1896: 'At the Flatts, Upper Lodge Farm... during the evening three balloons were successfully sent up which soared away to the west, until they were lost to sight in the distance.'

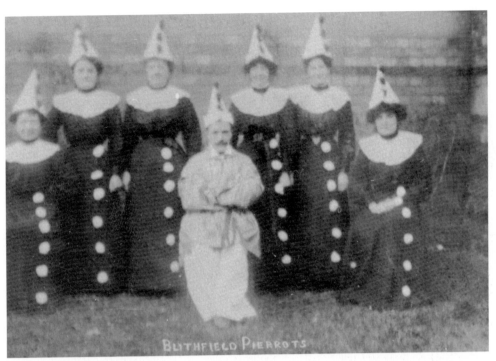

BLITHFIELD PIERROTS as seen in the production advertised in 1911. Blithfield and Admaston had a tradition of annual musical concerts fostered by the Revd D. Murray, the rector there for many years.

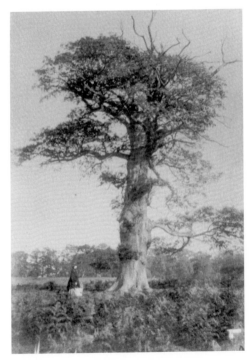

PHOTOGRAPHY WAS A VERY POPULAR PASTIME with the upper classes during the second half of the nineteenth century. This early photograph, one of a series, is of one of the ancient oaks in Bagots Park and was taken *c.* 1860.

SCHOOL ROOM, ADMASTON.

DRAMATIC & VARIETY ENTERTAINMENT
Saturday, February 11th, and Monday, February 13th, 1911, at 7-30 p.m.

Front Seats, 1/6; Second Seats, 1/-; Back Seats, 6d.

PROCEEDS FOR CLEANING CHURCH ORGAN.

✦✦✦ PROGRAMME. ✦✦✦

1 PIANOFORTE DUET ... Fairy Queen Sydney Smith
 Mrs. MARDELL and Miss HAWKSFORD.

2 SONG My Old Shako Trotère
 Mr. BRUMWELL.

3 PLAY Entitled—**"The Little Scamp Next Door."** .. Nance Newton
 (By Permission of Messrs. Heywood & Son).

Characters:

Harold Raymond—A Medical Student W. M. NEIGHBOUR
Jeremiah Juflkins—A Butcher E. M. DENNING
Miss Patricia Howard—An Old Spinster Miss HAMPSHIRE
Miss Marjorie Graham—Her Niece Miss NEIGHBOUR
Prudence Swift—Housemaid Miss D. NEIGHBOUR
 SCENE ... Miss Howard's Drawing Room.

4 SONG Oh, Flower of all the World ... Amy Woodforde-Finden
 Miss G. DENNING.

5 TOY SYMPHONY Romberg

6 SONG Piccaninny's Slumber Song ... Joseph Fredericks
 BLITHFIELD PIERROTS.

INTERVAL.

7 PIANO SOLO ... Danse des Moissonneurs D. R. Munro
 Miss M. NEIGHBOUR.

8 SONG The Little Hero Adams
 Mr. BRUMWELL.

9 PLAY Entitled—**"An Amicable Arrangement"** .. L. Mac Hale
 (By Permission of Messrs. Heywood & Son.)

Characters:

Ebenezer Scattergoods—Proprietor of a Millinery Establishment ...W. M. NEIGHBOUR
Matilda—His Wife Miss HAMPSHIRE
Selina—Their Daughter Miss NEIGHBOUR
Jack Goodier—A Portrait Painter D. NEIGHBOUR
 SCENE ... A Sitting-Room adjoining Scattergoods' Work-Room.

10 CHARACTER DUET ... Rainbow Henry E. Pether
 Mrs. MARDELL and Miss HAWKSFORD.

11 SONG Good-bye Mister Teddy Bear Harry Gifford
 BLITHFIELD PIERROTS.

Ticket Holders admitted at 7 p.m. No Tickets sold at the Door until 7-15 p m

BLITHFIELD CONCERT PROFRAMME, 1911.

114

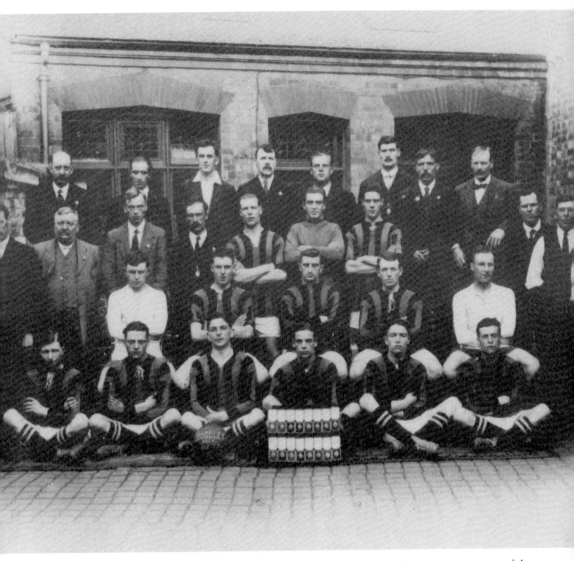

RUGELEY VILLA FOOTBALL TEAM, in 1922-3 season; the medals indicate it was a successful one for them.

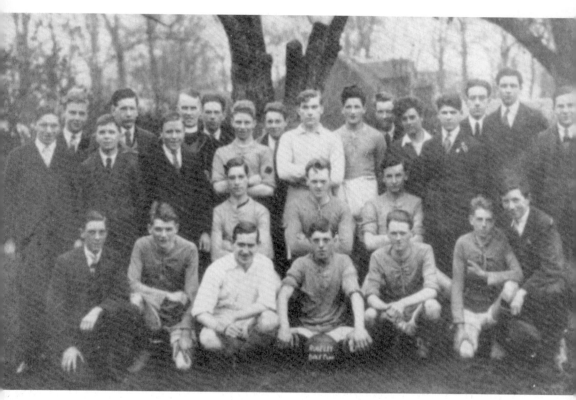

RUGELEY, ST AUGUSTINE'S BIBLE CLASS FOOTBALL TEAM, *c.* 1930. Revd H. Lowe, pictured here with the team, was the curate at St Augustine's from 1927–1940 and organized many activities, including the football team, for the young people of Rugeley.

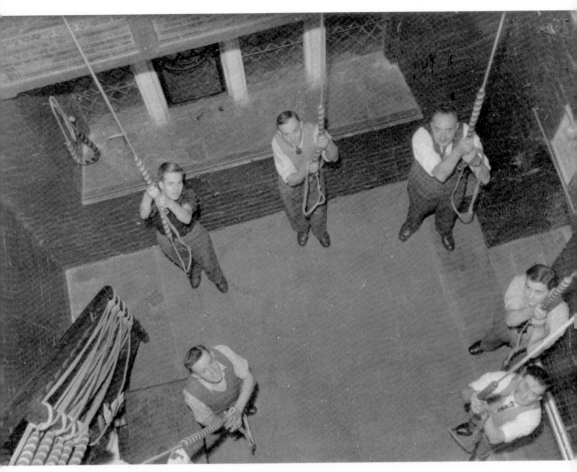

BELLRINGERS in the belfry of St Augustine's church, Rugeley, in the late 1950s.

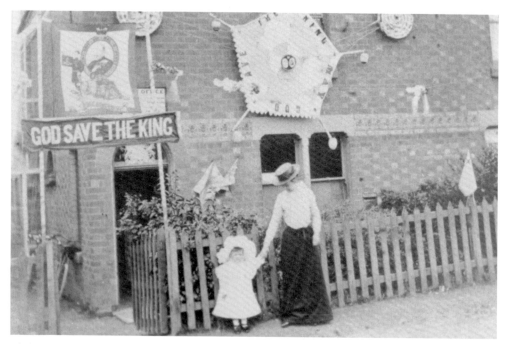

COTTAGE IN NEW ROAD, Armitage, decorated to celebrate the coronation of Edward VII in 1901.

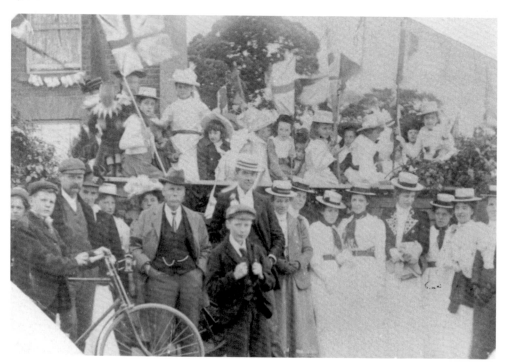

PART OF THE SAME CELEBRATION in Armitage.

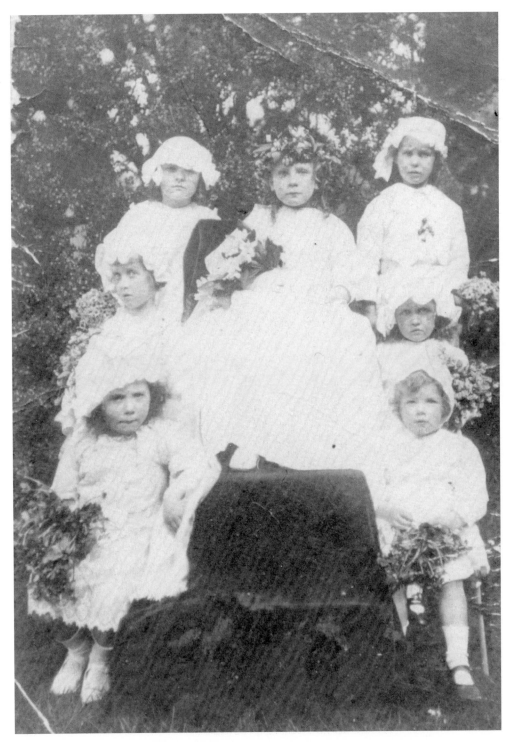

THE MAY QUEEN AND HER ATTENDANTS at Great Haywood in the early 1920s.

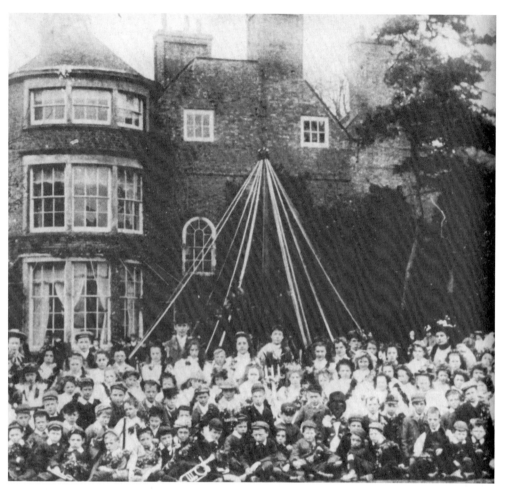

MAY DAY CELEBRATIONS at Colton in 1897. The boys dressed up as tradesmen, and the girls and the May Queen dressed in white, decked with flowers.

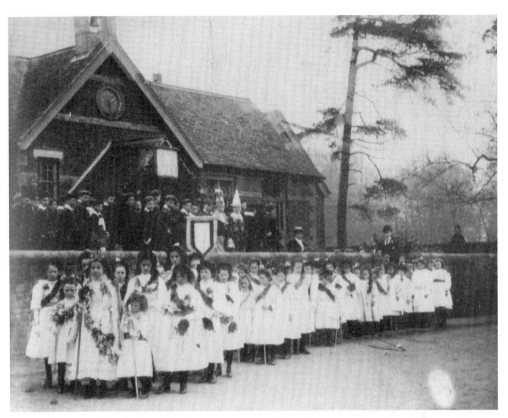

COLTON MAY DAY CELEBREATIONS in 1899. This photograph was taken at the back of Colton Hall, the home of Frederic Bonney. The Maypole was erected in his garden for the children. He took the photograph shown here.

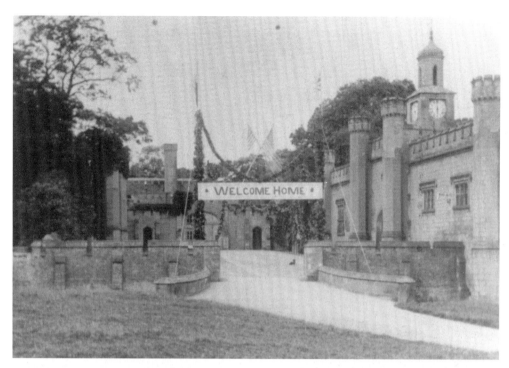

CELEBRATIONS TO MARK THE HOMECOMING (above and below) to Blithfield Hall of William, fourth Lord Bagot, after his marriage to Lilian Marie May of Maryland, USA, in July 1903. Note the United States flags to welcome the American Lady Bagot.

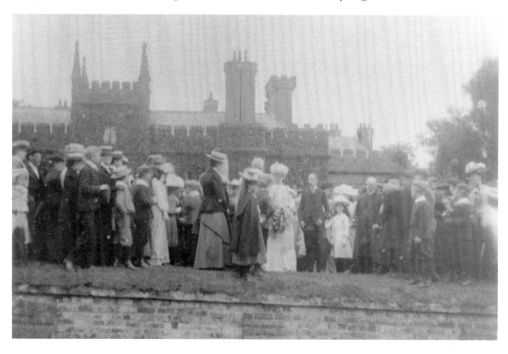

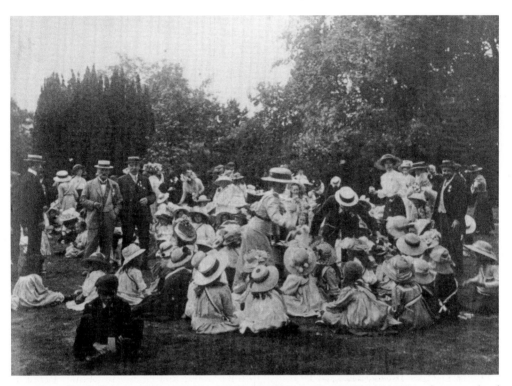

CELEBRATING THE CORONATION OF GEORGE V AND QUEEN MARY in the grounds of Armitage Lodge in 1911. The children are from the National School.

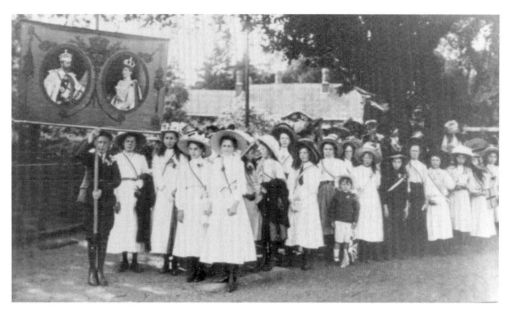

CHILDREN FROM THE NATIONAL SCHOOL, decked in red, white and blue ribbons, join the coronation celebrations at Armitage Lodge in 1911.

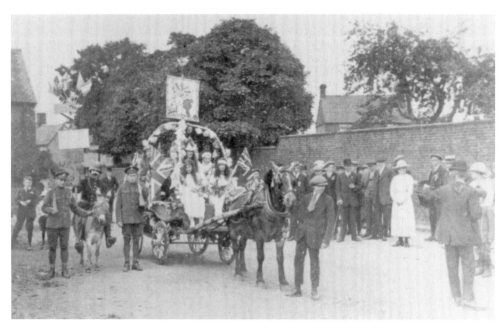

PEACE CELEBRATIONS on the Green, Handsacre, 1919.

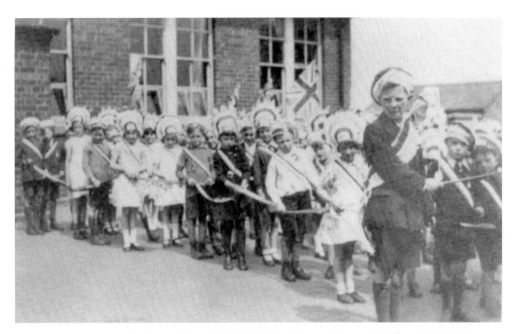

CHILDREN OF ARMITAGE COUNCIL SCHOOL celebrate George V's Silver Jubilee in 1935.

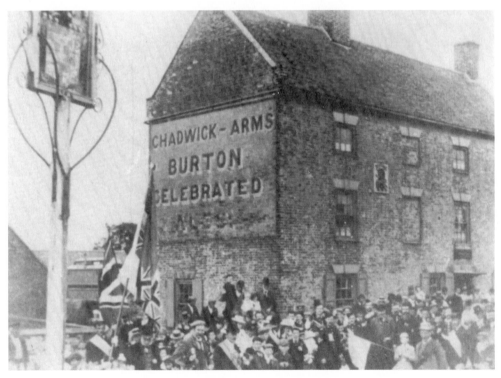

CELEBRATION OUTSIDE THE CHADWICK ARMS, Hill Ridware, believed to be for the Silver Jubilee of Queen Victoria, 1897.

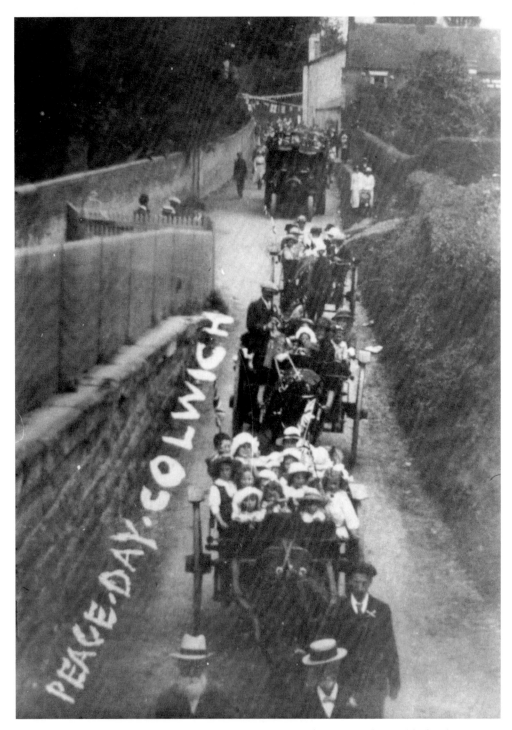

CELEBRATORY PROCESSION IN MEADOW LANE, Little Haywood, possibly for the peace at the end of the Boer War, 1902.

ACKNOWLEDGEMENTS

It would not have been possible to bring together this collection of photographs without the generosity, help and time of a number of people.

Firstly we must express our grateful thanks to the late Mrs May Grimley, who allowed us, without reservation, to draw extensively upon her knowledge and her collection of old photographs of Armitage and Handsacre, built up over many years. We are only sorry that she did not live to see this book.

Secondly, we would like to thank Nancy, Lady Bagot, for her kindness in searching out and allowing us to use a number of her private photographs of Blithfield Hall and Park and for extensive information given so freely. The Haywood Society and the Staffordshire Schools History Service have also allowed us to draw on their photographic collections, for which we are grateful.

The following individuals and organisations have generously loaned photographs for publication and have often provided us with information to accompany them:

Mr A. E. Anslow • Armitage Shanks Ltd. • Mr S. Ball • Mr J. Burke • Mrs M. Chell
Mrs M. E. Corden • Mrs D. Ecclestone • Mr T. T. Field-Williams • Mr J. Godwin
Mr T. Heatherley • Miss D. Jones • Mr R. W. Knight • Miss D. Landor • the Landor Society
Mr R. A Lewis • Mr A Lloyd • Mrs G. K. McLeavy • Mr G. Mellor • Mrs M. Murdock
Major D. Parker • the late Mr & Mrs Phillips • Miss Radford • the late Mr C Robinson
Mrs M. Smith • Mrs M. Wharne • Mrs R. Williams • Mr W. G. Wright.

We would also like to acknowledge help received in various ways from the following:

Miss C. Bramwell and the staff of Rugeley Library • Mr and Mrs D. Butcher • Mr C. Ecclestone
Mr C. Ferguson • Mr A. Gough • Mrs P. Hill • Mr A. Noel • Mrs L. Taylor • Mr G. Vernon
the Editor of *Compass* magazine • the County Archivist at Staffordshire County Record Office.